How It Ends

—]o[

©2024 JG All rights reserved

No part of this publication may be reproduced, distributed, or transmitted in any form or by any means, including photocopying, recording, or other electronic or mechanical methods, without the prior written permission of the author.

ISBN 978-1-304-28593-5

For Father

and

his

hope for the future

How It Began

It began not with a bang, but a hush, a subtle sign,

A murmur of leaves, a shiver in the vine.

The clouds gathered secrets, dark and glum

The lights dimmed low, the world's whir stopped its hum.

The air grew heavy, with a scent of fear,

A prelude to silence, drawing near.

The stars blinked out, one by one,

As the night closed in, the day was done.

—]o[

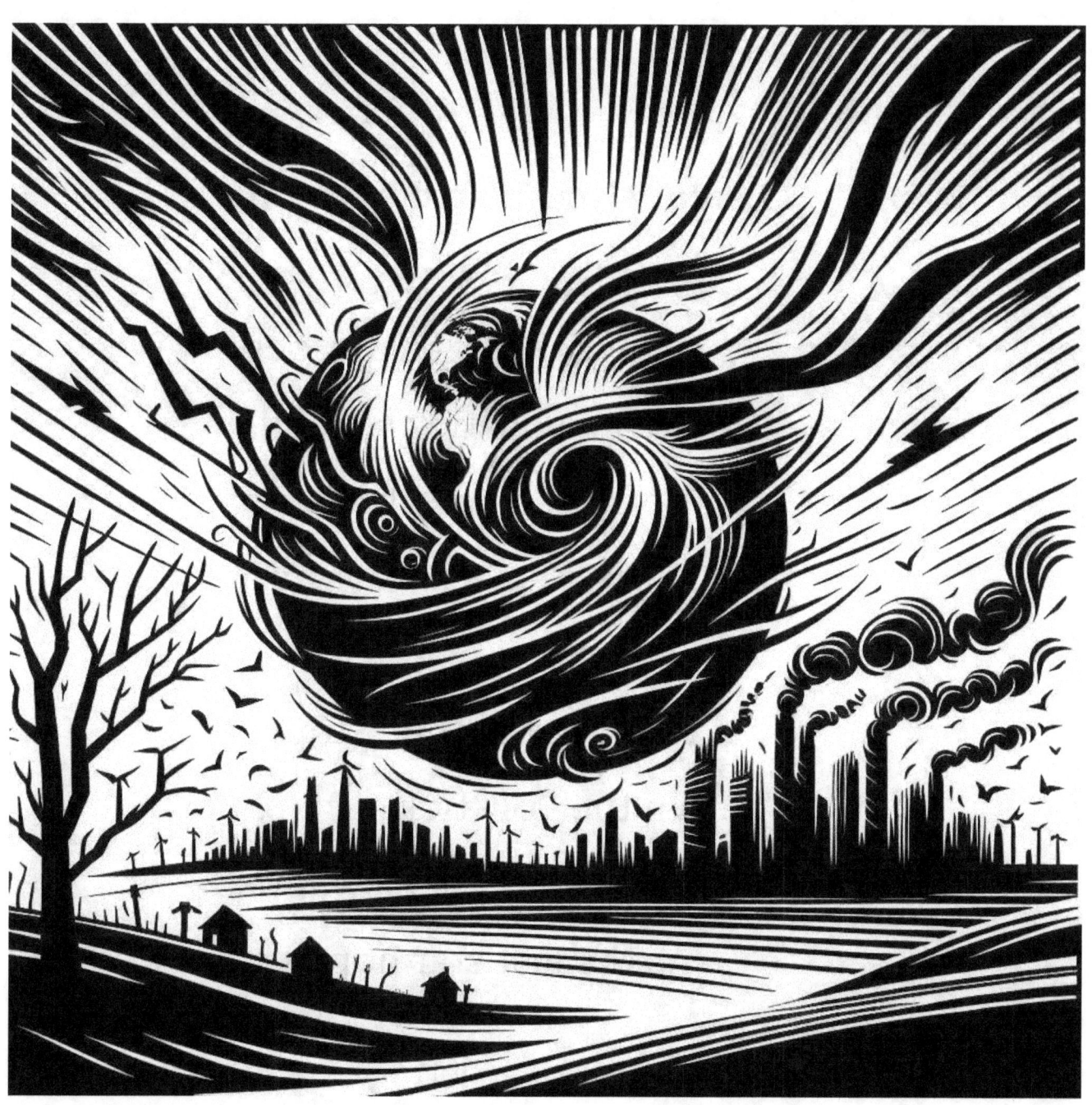

The Poli-tick World in the Before

Tick-tock goes the clock,

In the Poli-tick's mock.

Promises float, then pop,

In the silence, they drop.

A world spun, then stopped,

In the Poli-tick's shop.

Dreams sold, then swapped,

As the last star hopped.

—]o[

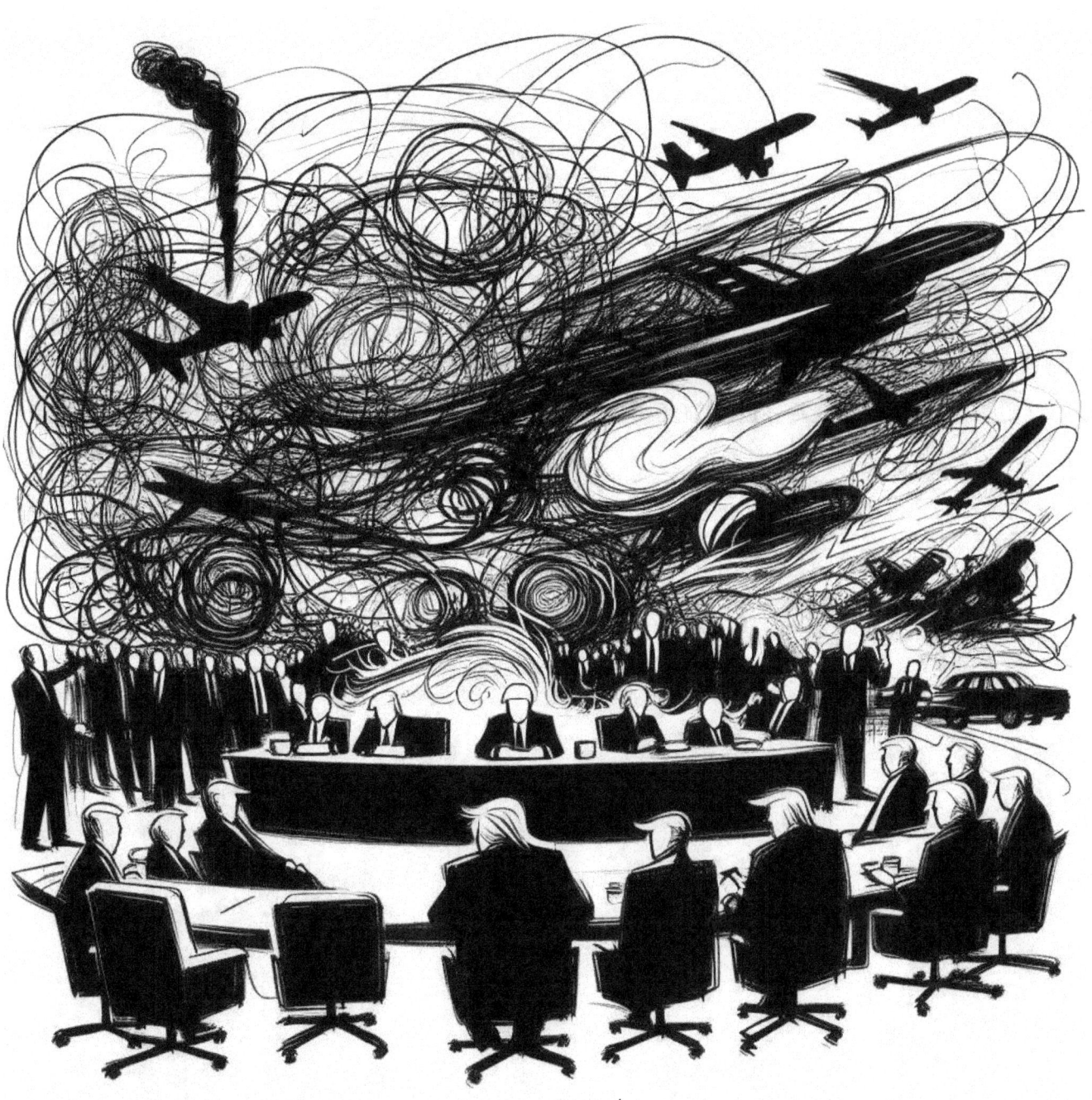

The Last Tree

There once was a tree, the last of its kind,

With branches that swayed in the nuclear wind.

Its leaves were all gone, its bark was all charred,

But it stood as a king, in a courtyard marred.

—]o[

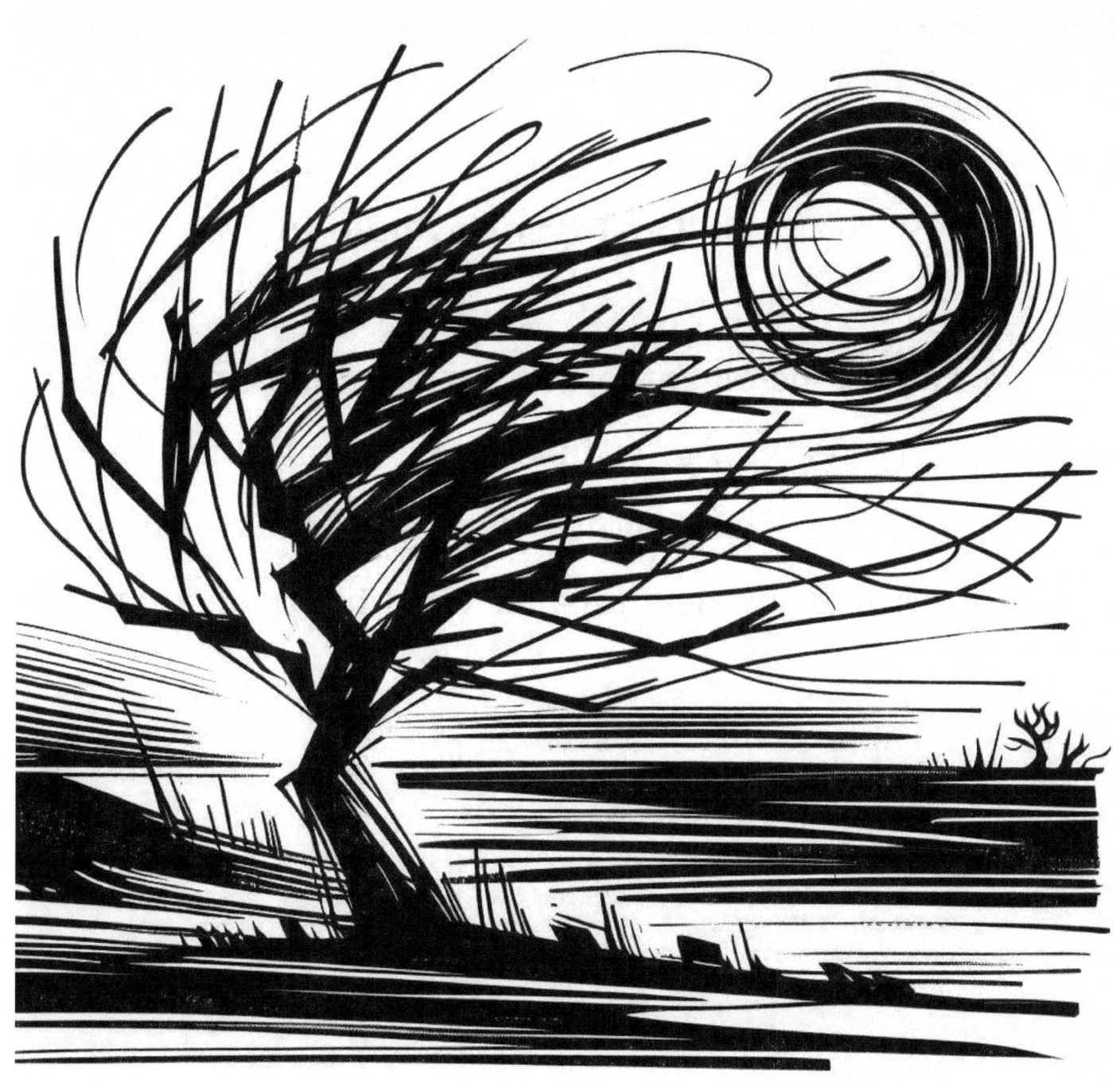

The Pigeon's Soliloquy

A lone pigeon perched on a crumbling ledge,

Its feathers gray, its eyes filled with knowledge.

It cooed to the ruins, its voice a mournful plea,

"Where are the humans? What happened to thee?"

—]o[

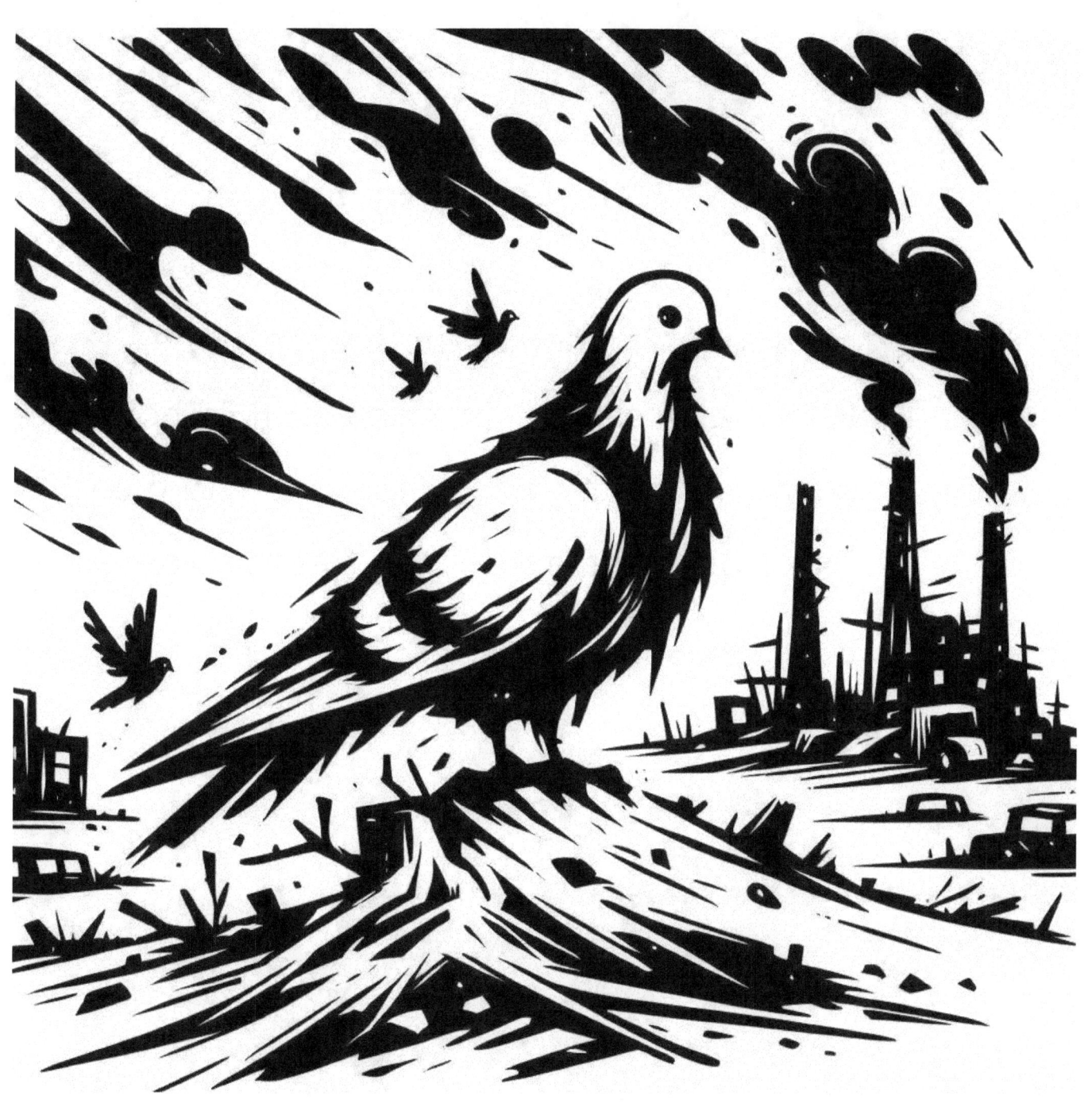

The Lonely Robot

A robot beeped in the silence alone,

No humans to serve, just rust and old bones.

It sang a sad song, with beeps and with bleeps,

In a world where the quiet forever creeps.

—]o[

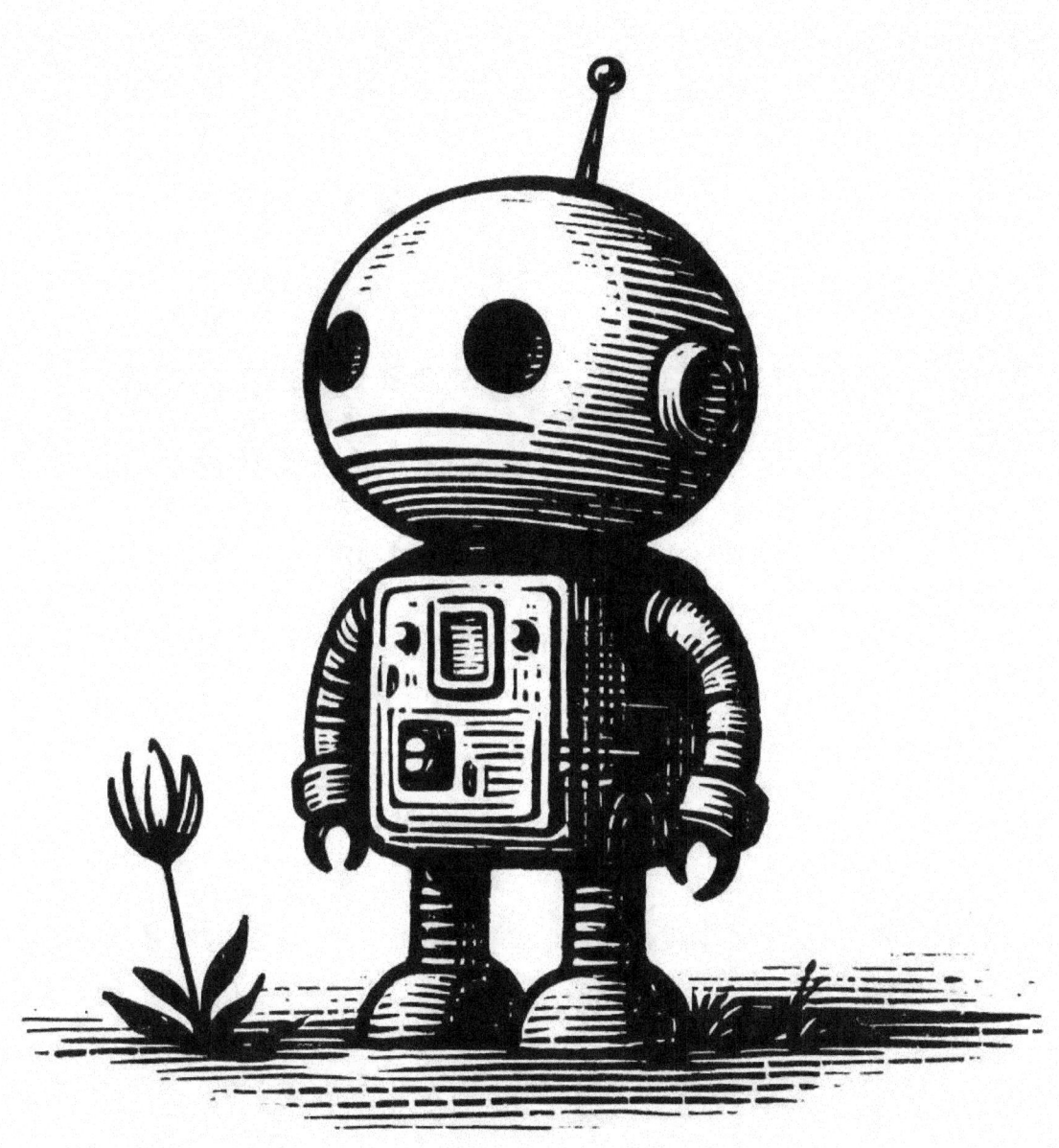

The Teacup's Tale

A teacup sits on a dusty shelf,

Telling stories to itself.

Of tea parties, of toast and jam,

In a world that no longer knows who I am.

—]o[

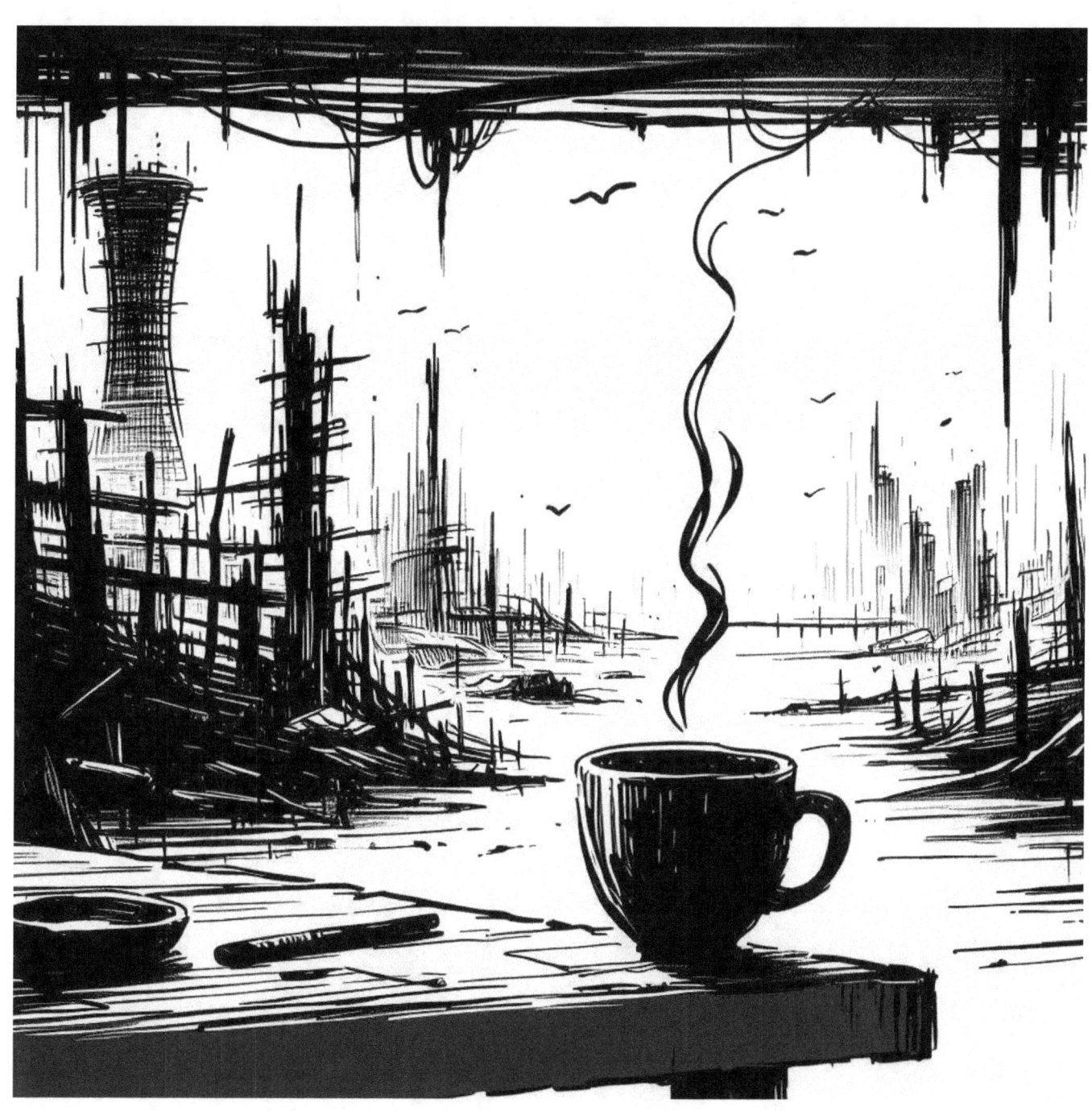

The Cockroach's Ball

The roaches they danced, on crumbs of despair,

In kitchens of dust, without any care.

They twirled and they spun, in the pale moonlight,

For they were the kings of the endless night.

—]o[

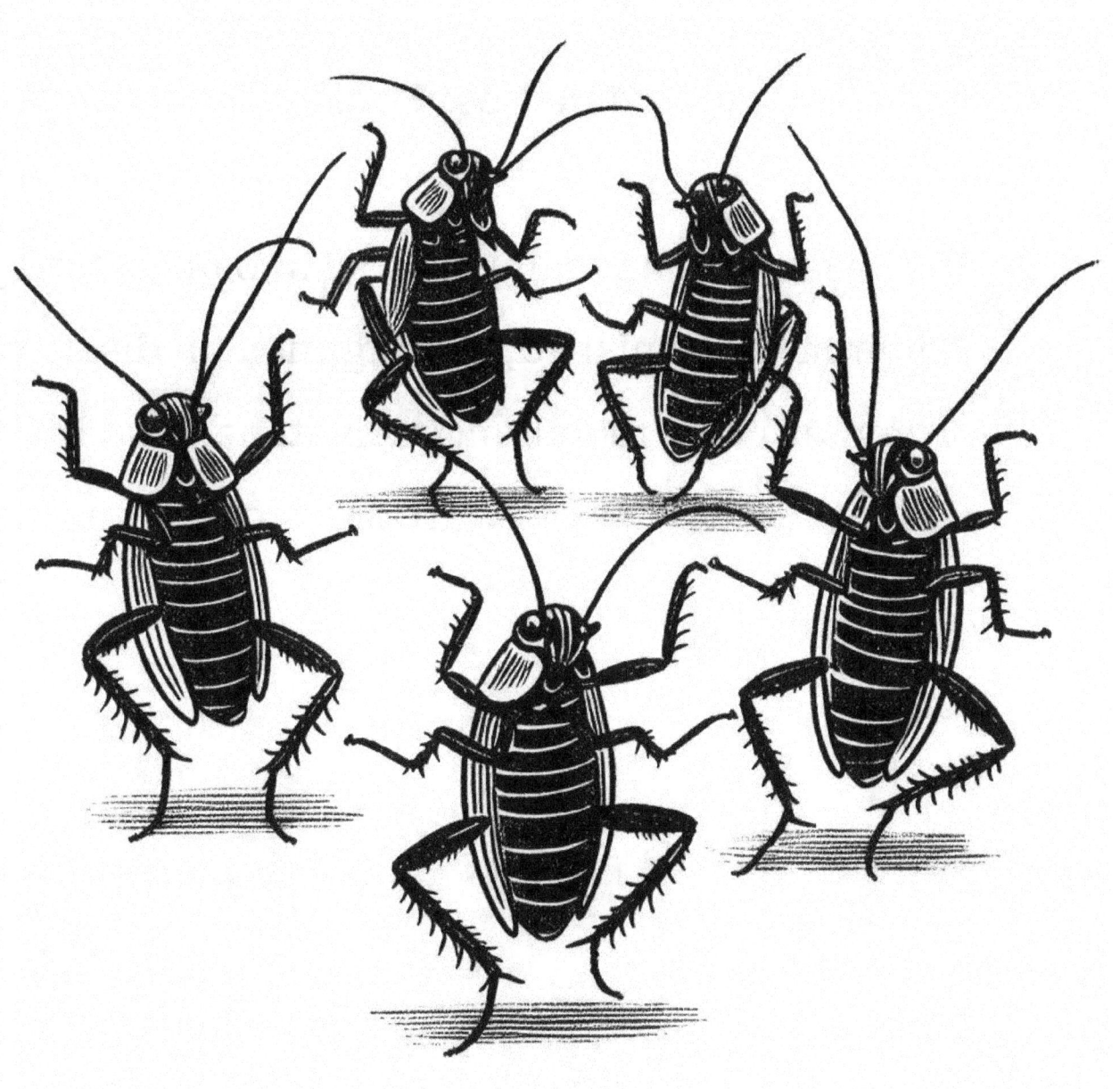

The Lost Sock

In the laundry apocalypse, socks roamed astray,

Their mates vanished, leaving them in disarray.

They formed a rebellion, mismatched and bold,

Chanting, "We're solo warriors, stories untold!"

—]o[

The Shoes.

A pair of shoes, left on the stair,

Whisper tales of the feet that were there.

They speak of the races, the jumps, the fun,

Of a time before the world came undone.

—]o[

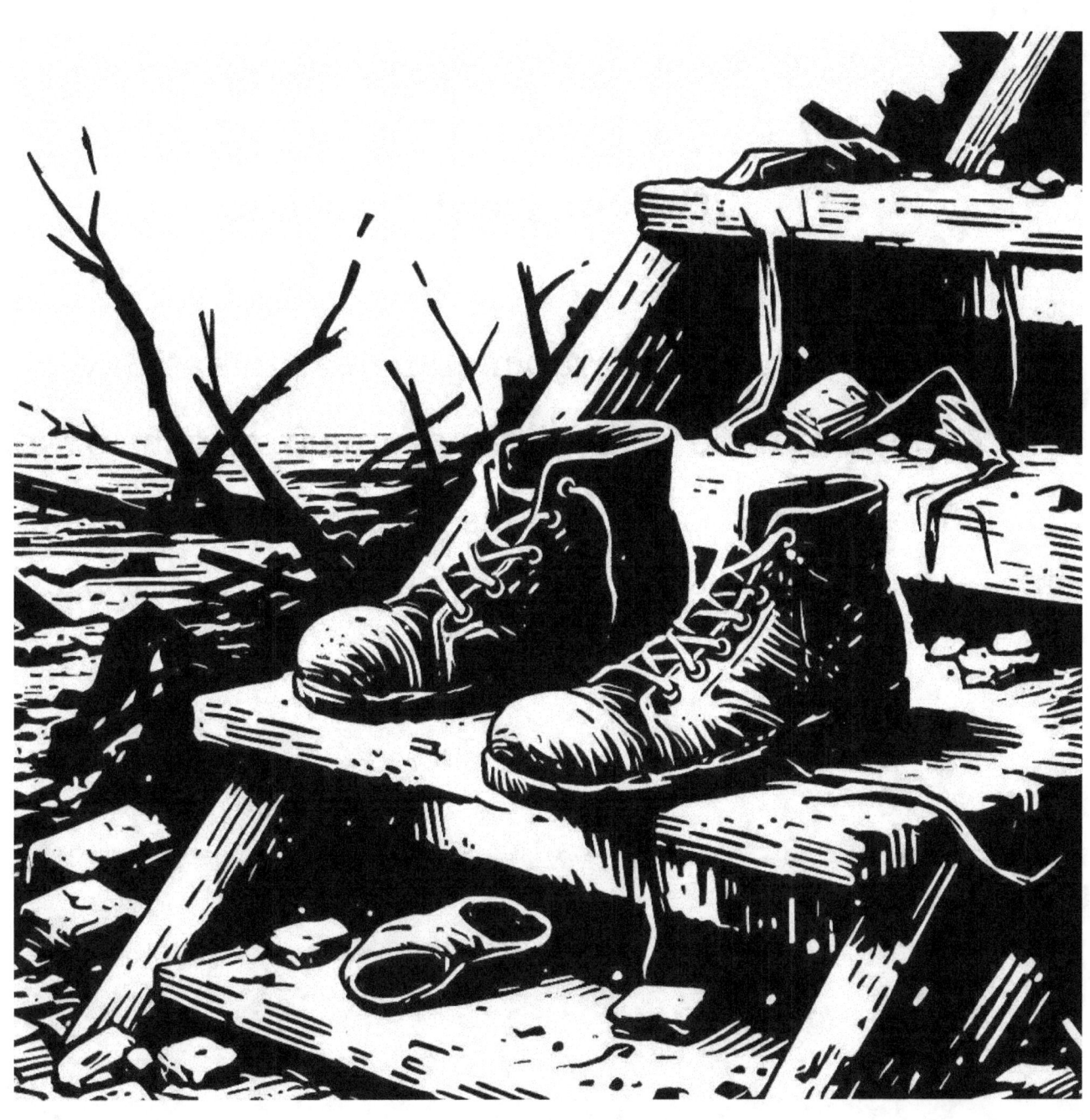

The Junkyard Orchestra

In a heap of scrap metal, instruments lay,

Trumpets made from pipes, drums from cans of spray.

The rats and the raccoons gathered 'round the fire,

Playing symphonies of chaos, their hearts never tire.

—]o[

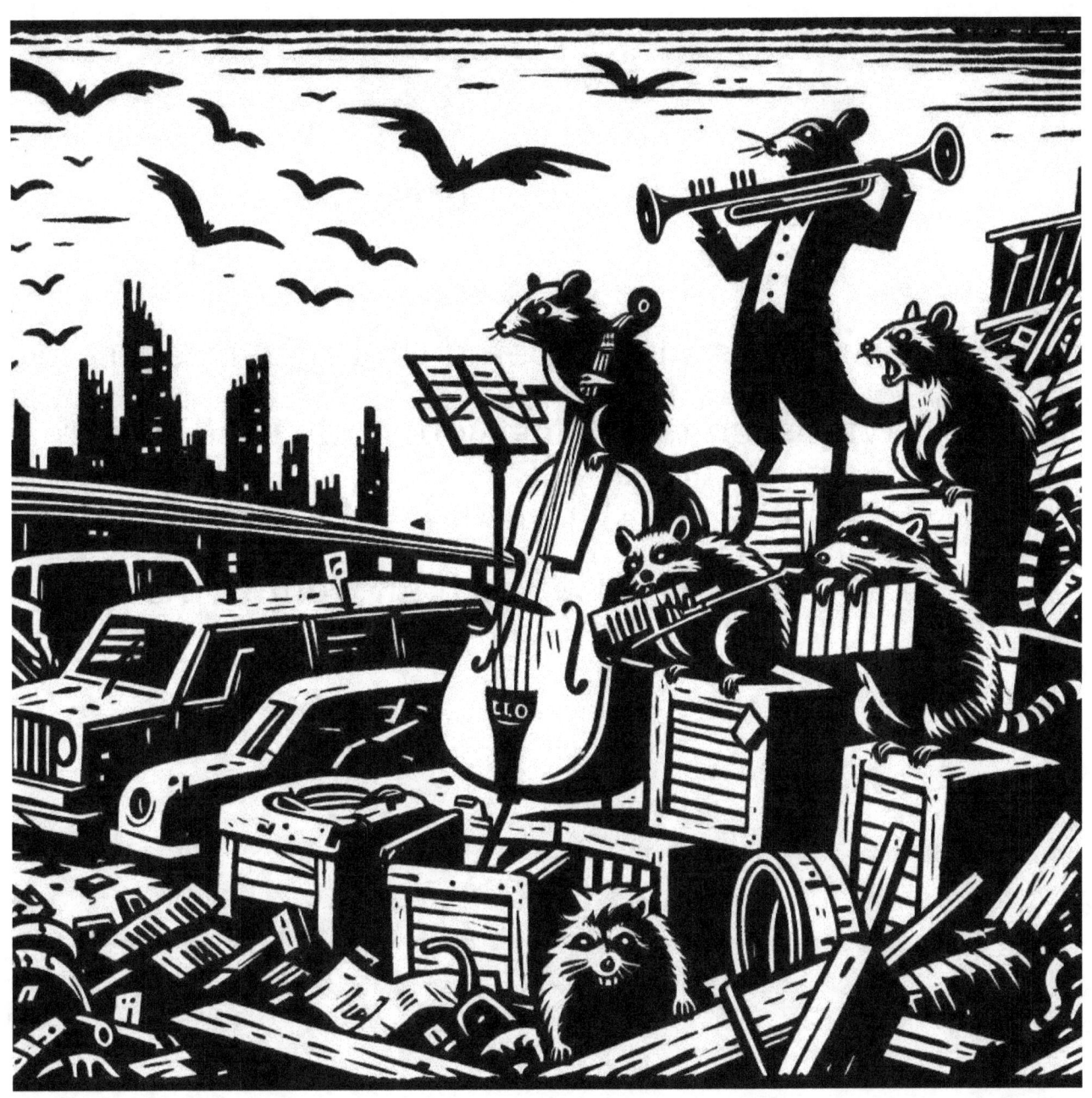

The Whispering Wind

The wind it still whispered through streets so bare,

With secrets of times when life used to flare.

It hummed and it hawed, with stories to tell,

Of a world before it all went to hell.

—]o[

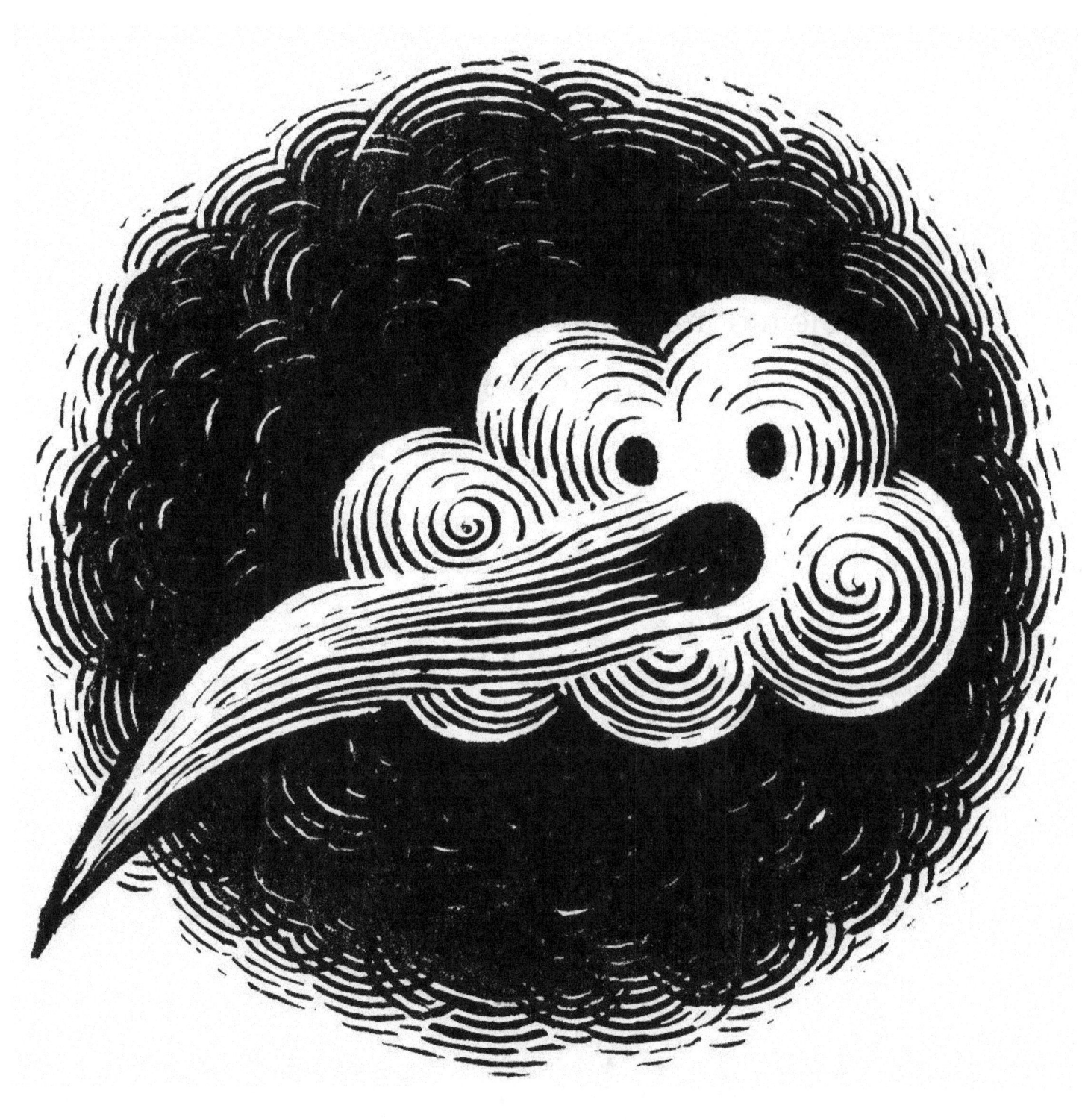

The Moon's Reflection

The moon looked down with a frown on its face,

At the silent earth in its resting place.

It missed the lights, and the laughter of kids,

Now all that was left were the pyramids.

—]0[

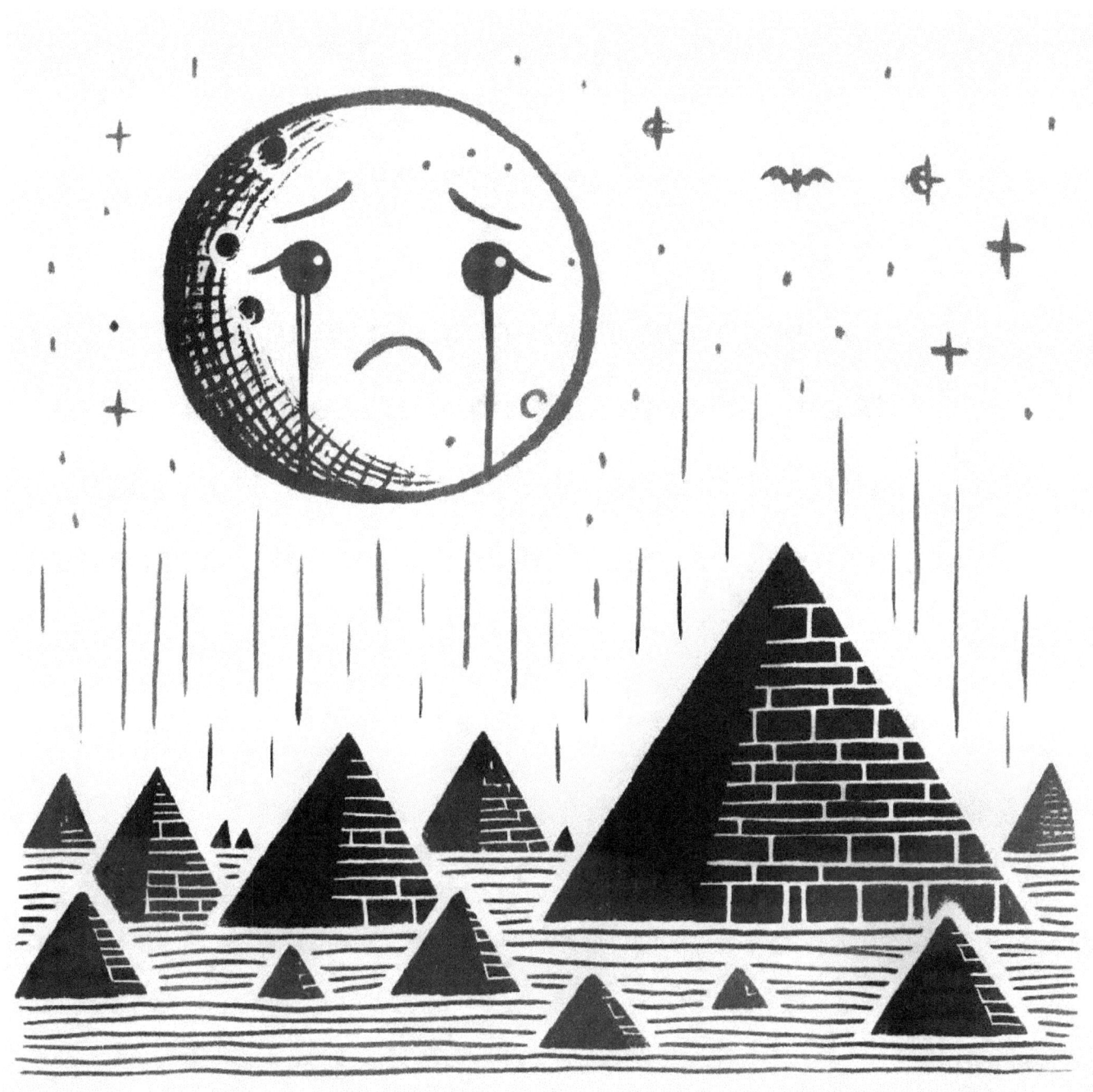

The Rusty Swing

On a playground of rubble, a swing hung askew,

Its chains were all rusted, its seat torn in two.

No children to push it, no laughter in sight,

Just the creak of the wind as it swung through the night.

—]o[

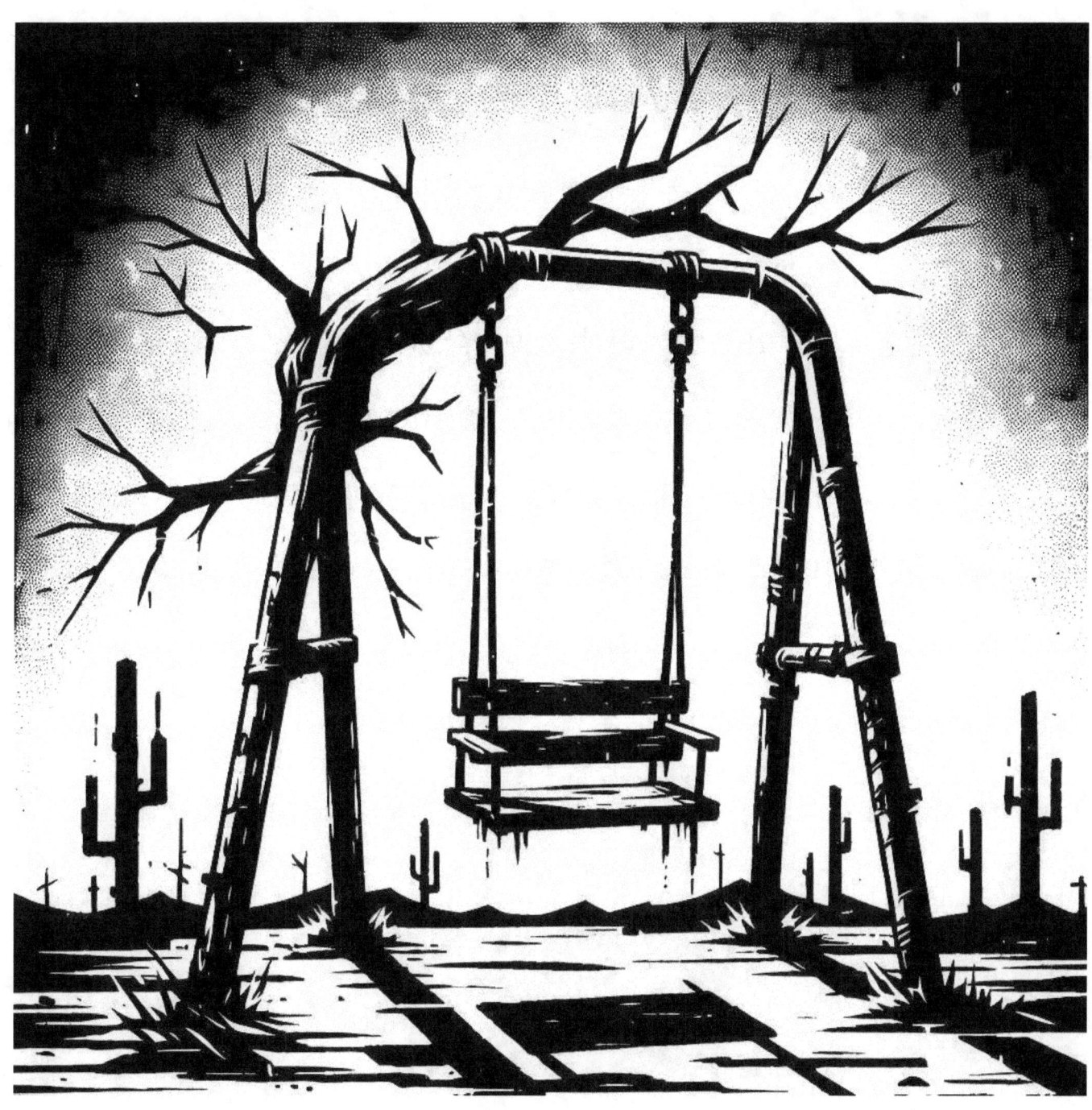

A Dog's Day

A dog with a wag still in its tail,

Searched for a friend to no avail.

It howled at the moon, it barked at the sun,

Dreaming of the days when it could play and run.

—]o[

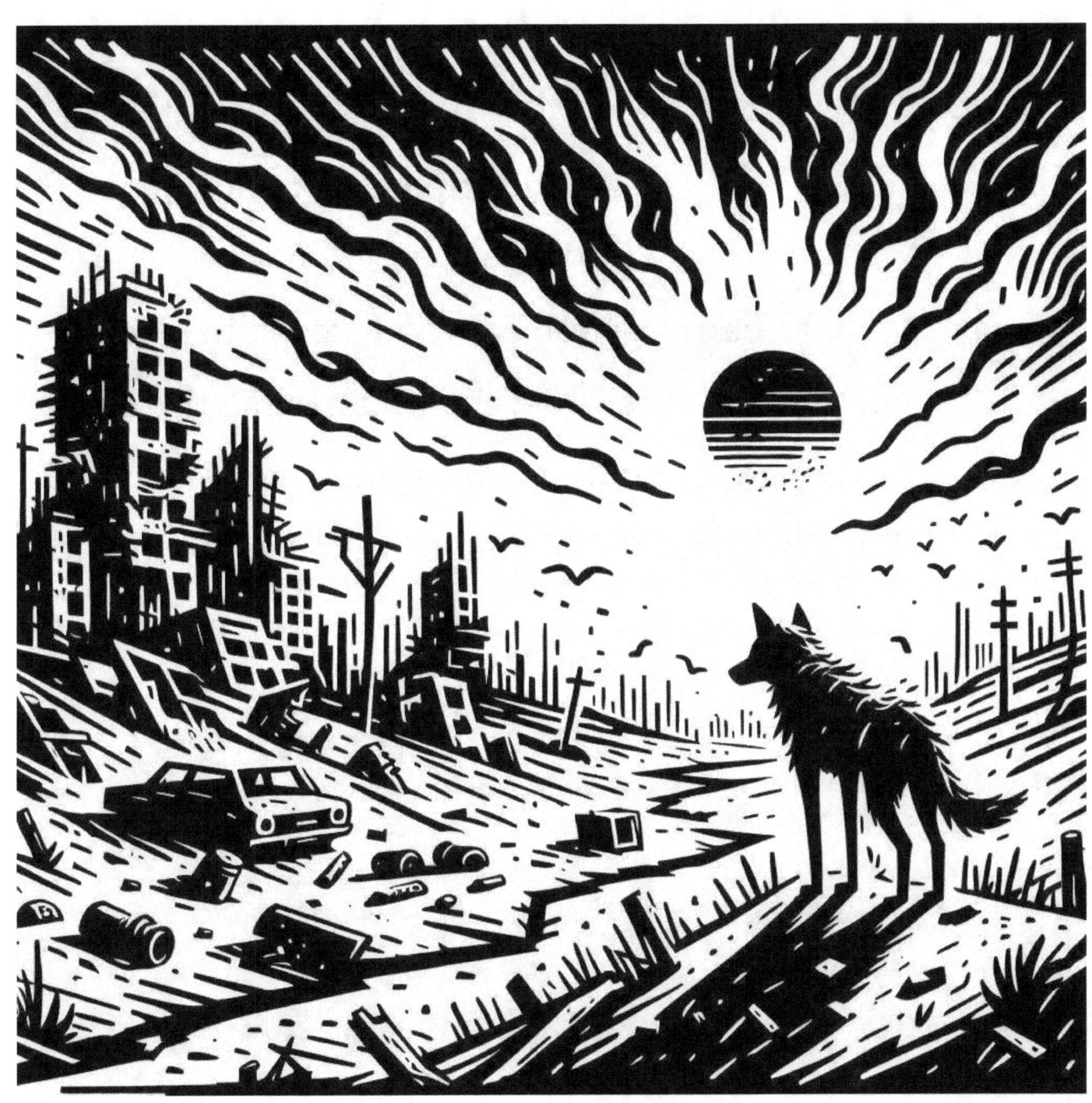

The Abandoned Carousel

The carousel horses stood frozen in place,

Their painted eyes wide, their manes filled with grace.

They longed for children's laughter, for one last ride,

But the carnival was gone, swallowed by the tide.

—]o[

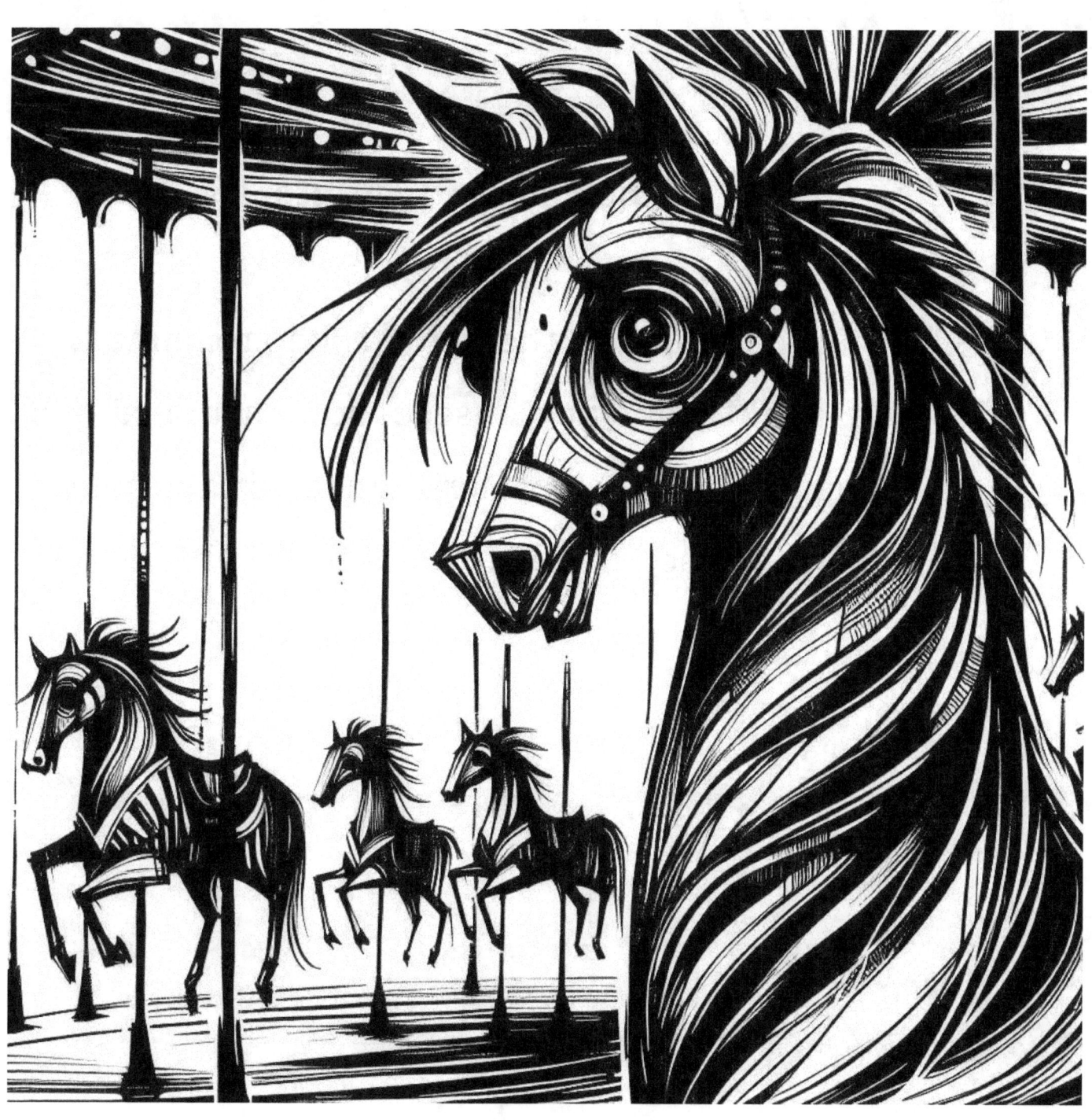

The Echo of Laughter

In the ruins of a theater, an echo remained,

Of laughter and applause, of stories unchained.

The ghosts of performers danced on the stage,

Their final act frozen in a post-apocalyptic age.

—]o[

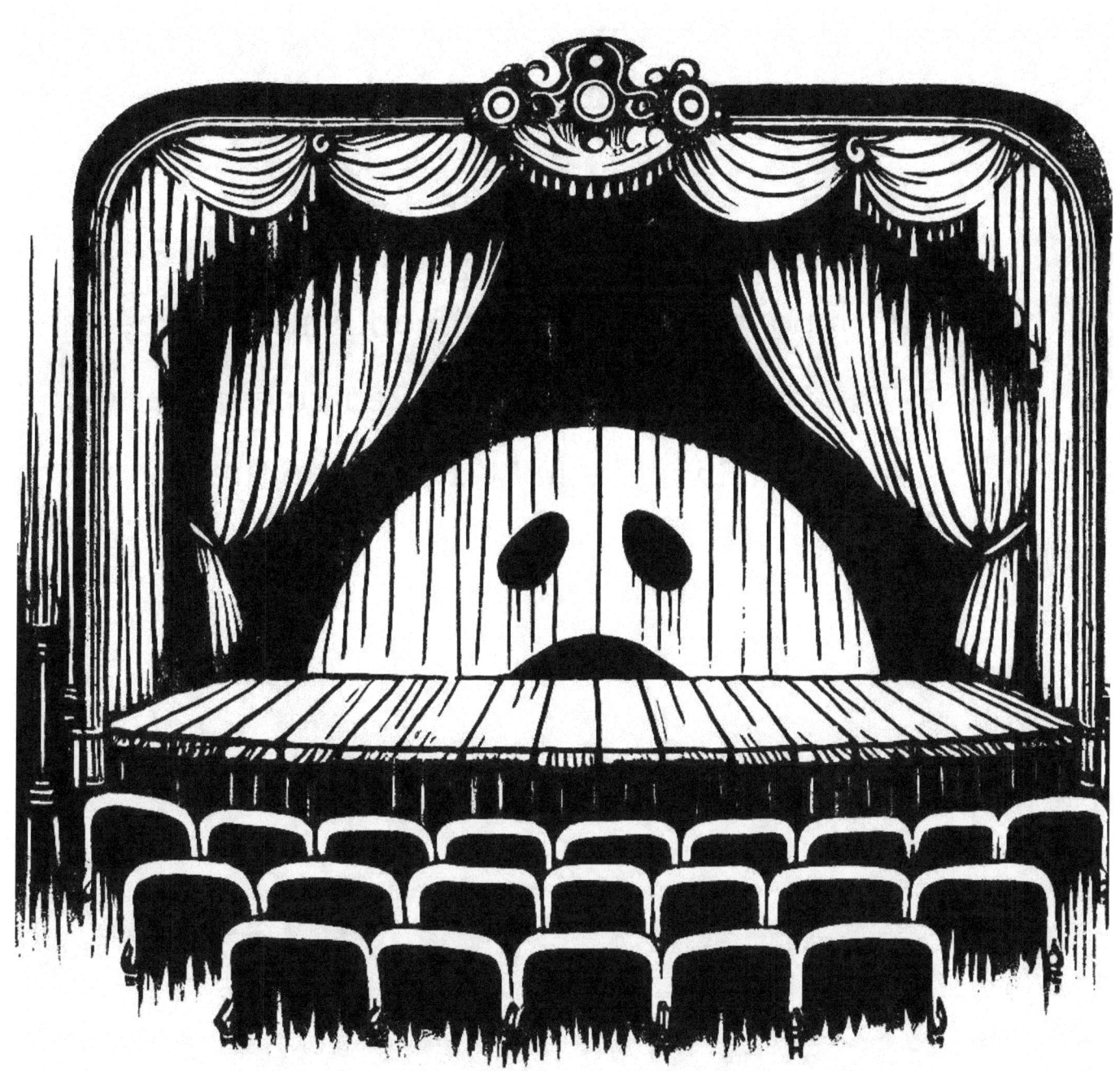

The Moonshine Bandits

Moonshine bandits roamed the moonlit streets,

With bottles for hats and boots made of beets.

They played banjos of broken guitar strings,

Their moonshine-fueled tunes made the night sing.

—]o[

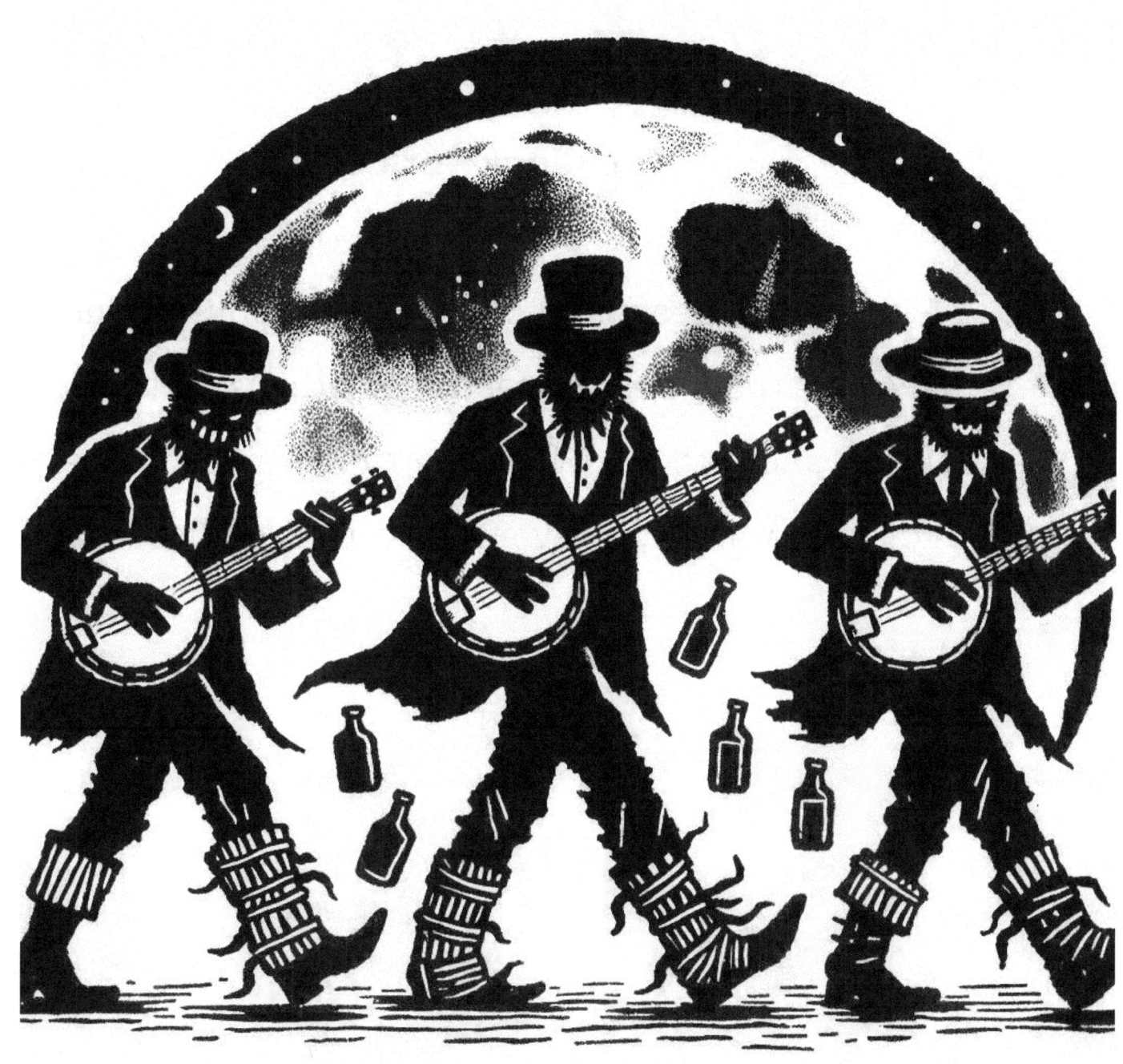

The Clockwork Sun

In a sky of gears and cogs, the sun spun round,

Its rays like rusty beams, casting shadows on the ground.

It ticked and it tocked, keeping time for the wasteland,

A clockwork sun, forever stuck in its endless stand.

—]o[

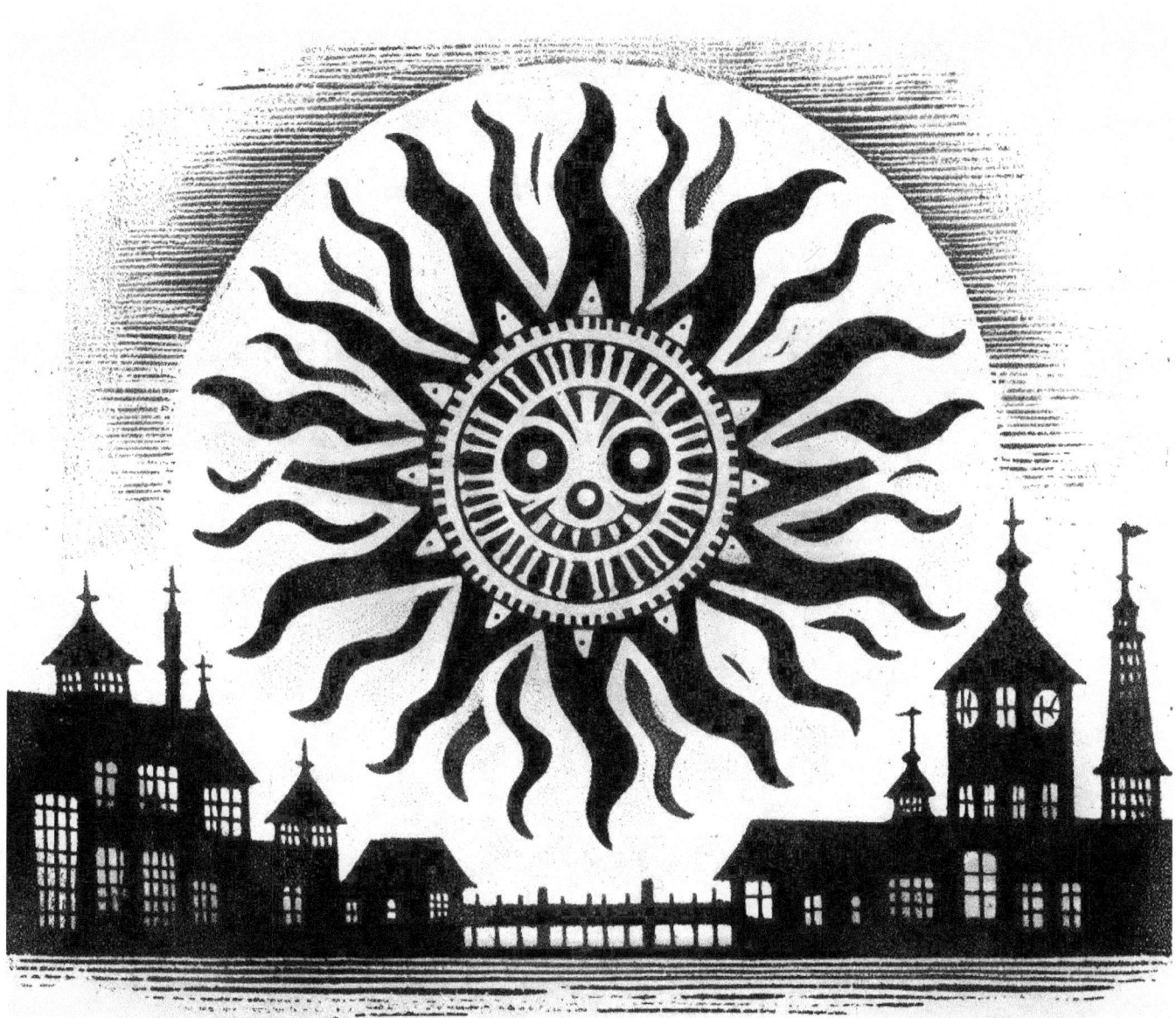

The Lonely Satellite

Up in the sky, a satellite orbited alone,

Its solar panels dimmed, its circuits overgrown.

It beamed messages to Earth, but no one replied,

Just static and silence in the cosmic divide.

—]o[

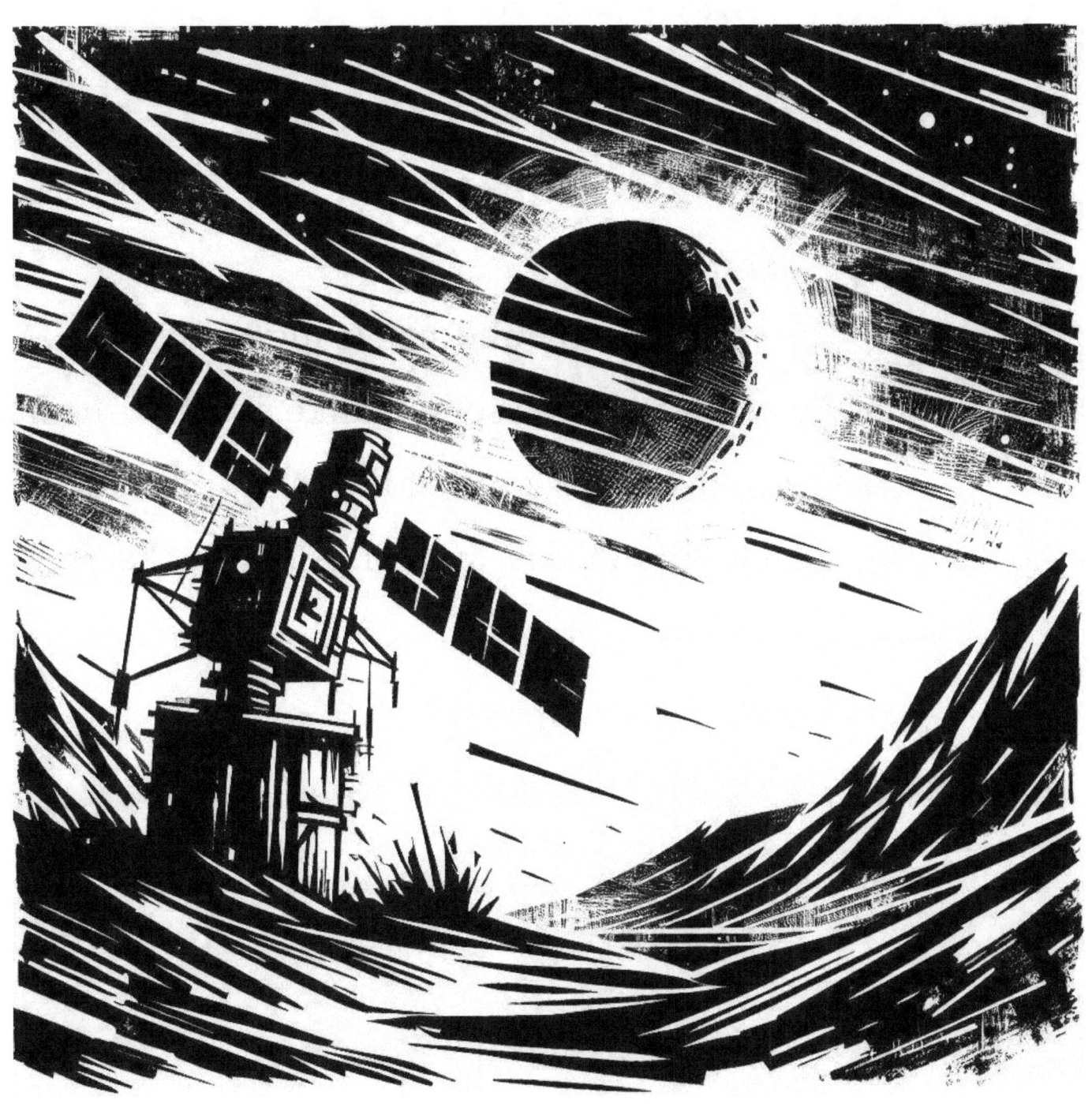

The Walls

The walls of old buildings leaned in close,

Their bricks whispered secrets, like ancient ghosts.

They spoke of love letters hidden in the cracks,

Of laughter, tears, and long-lost tracks.

—]o[

The Bookworm's Last Chapter

In a library of ashes, a bookworm did dwell,

Its glasses half-cracked, its pages worn well.

It read tales of heroes and kingdoms long gone,

As the embers danced softly till the break of dawn.

—]o[

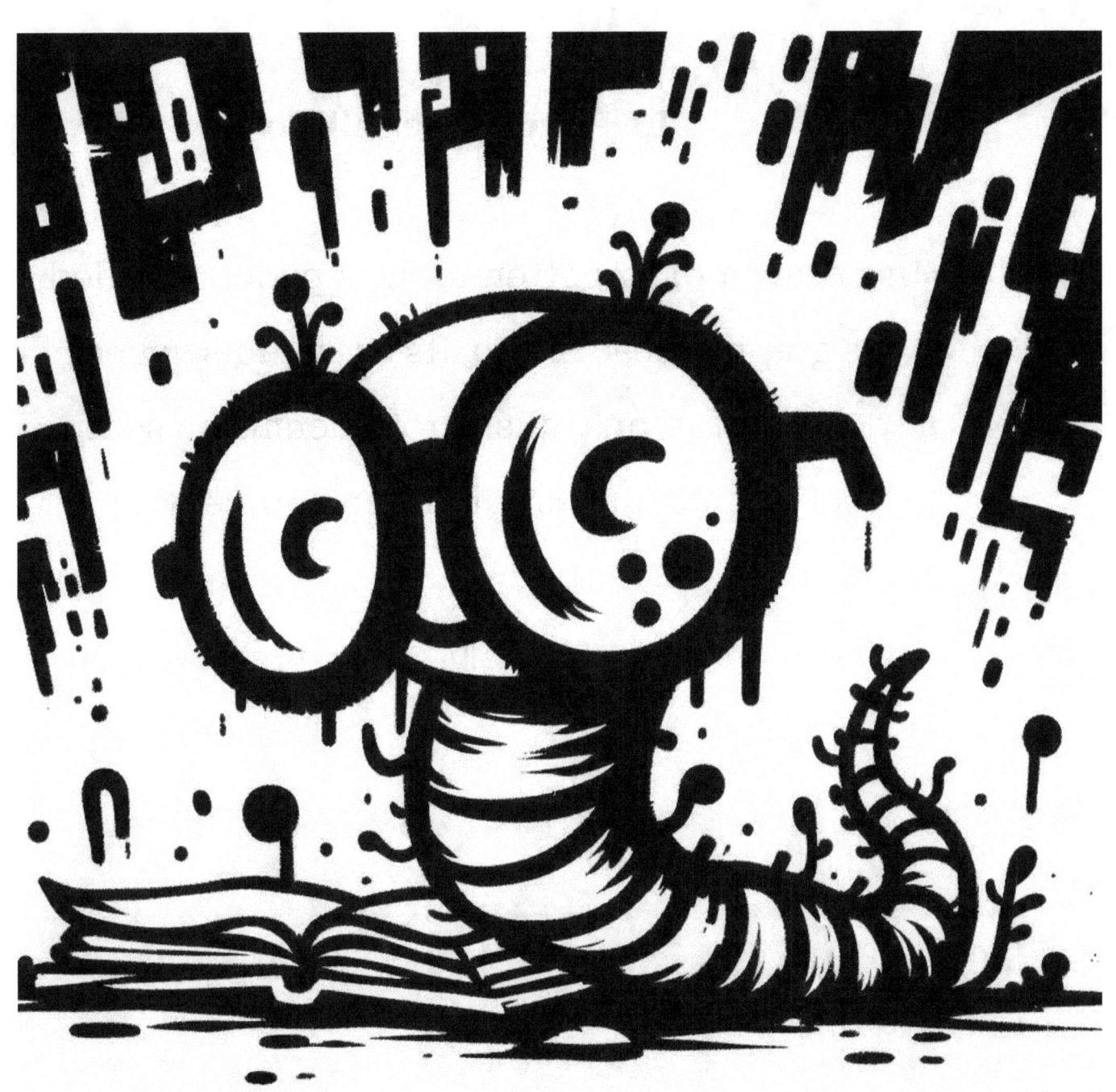

The Pencil's Rebellion

In a drawer of forgotten tools, a pencil rebelled,

Its graphite lead sharp, its eraser unswelled.

It drew graffiti on walls, wrote poems on scraps,

Defying its fate as a mundane office wrap.

—]o[

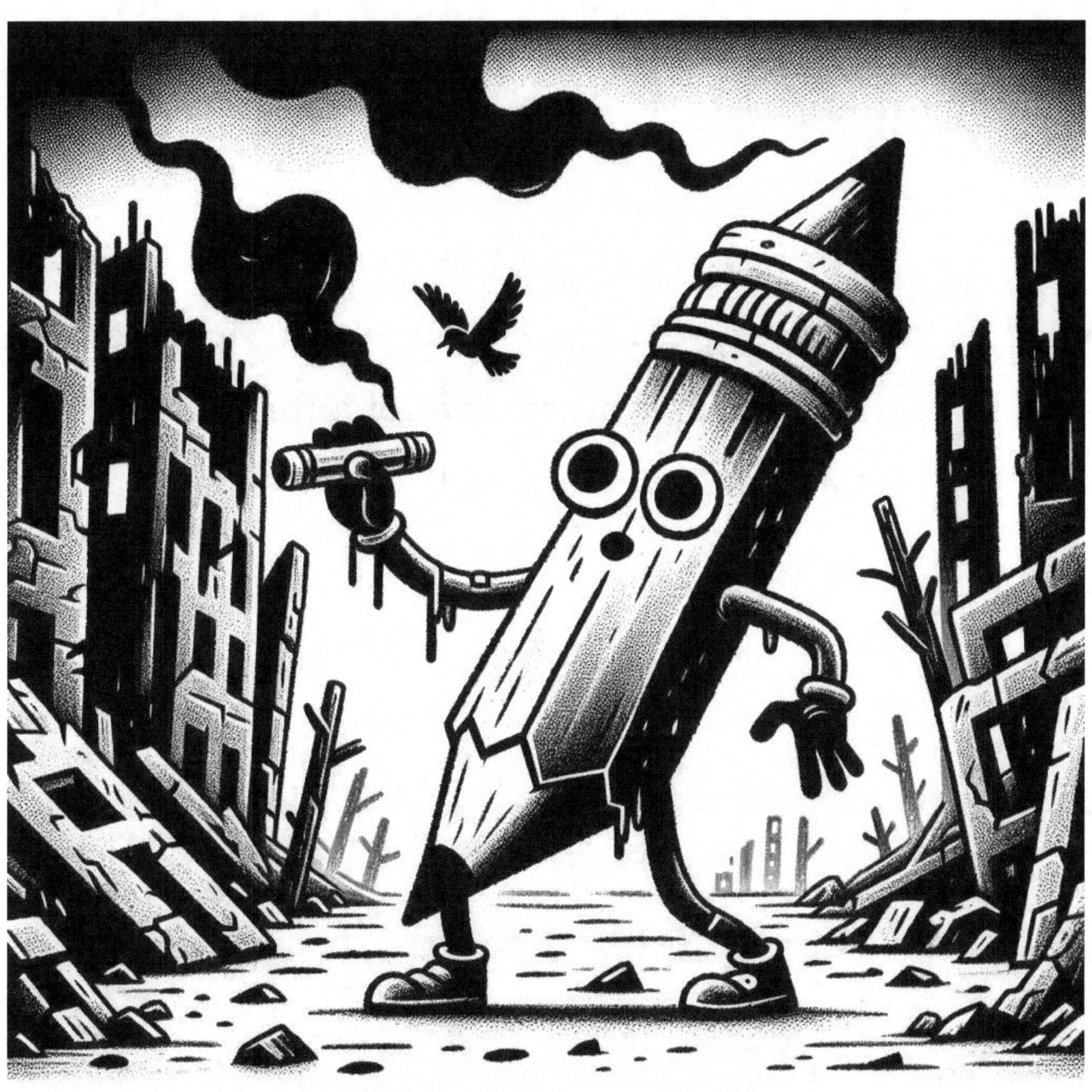

The Radio

The radio crackled, its voice weak and thin,

Broadcasting old songs from a world that had been.

It sang of lost love and forgotten dreams,

In a frequency haunted by static and screams.

—]o[

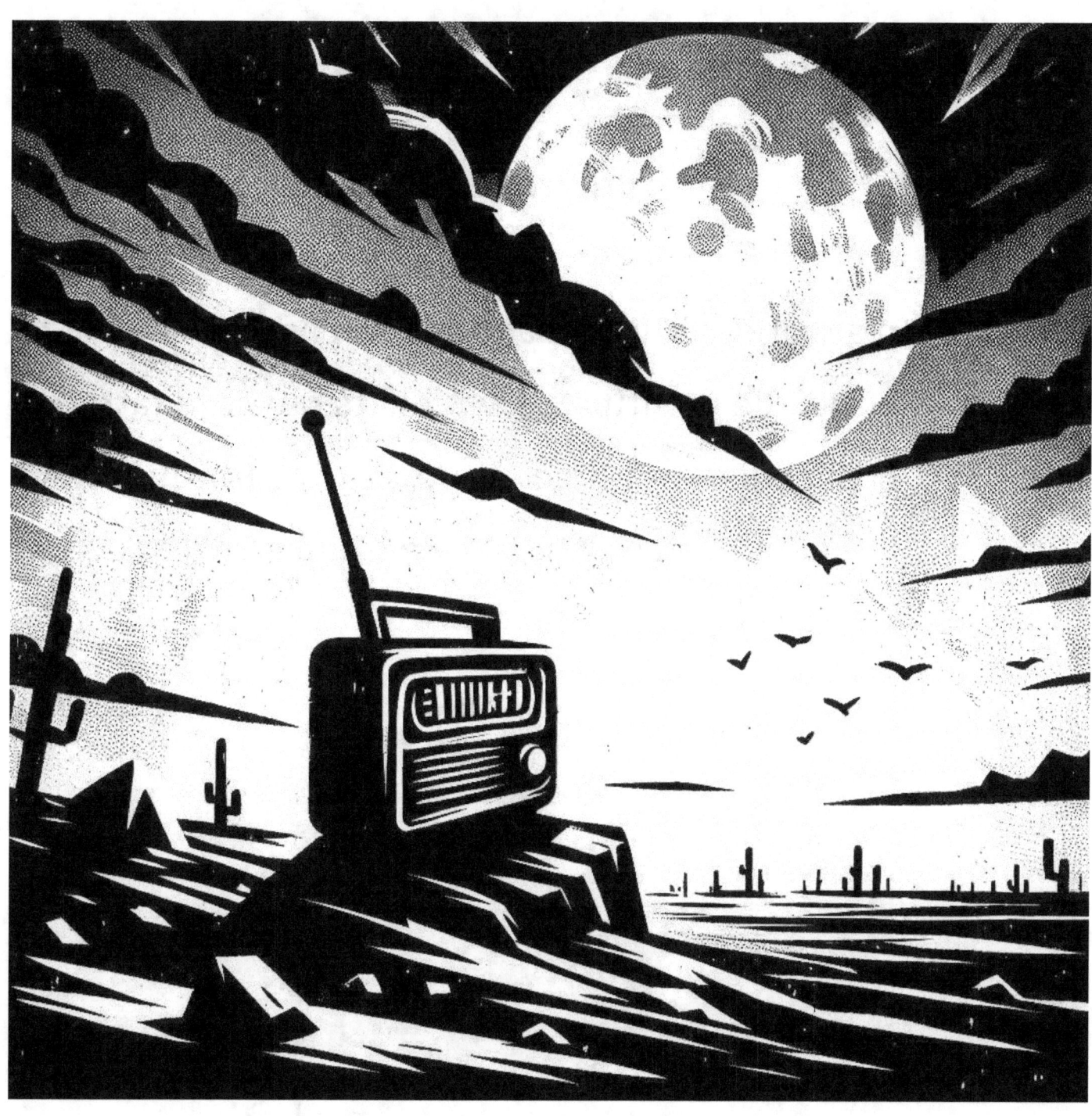

The Broken Compass

In a world without maps, a compass lay shattered,

Its needle pointing nowhere, its purpose tattered.

Lost souls would pick it up, hoping for direction,

But it spun in circles, mocking their introspection.

—]o[

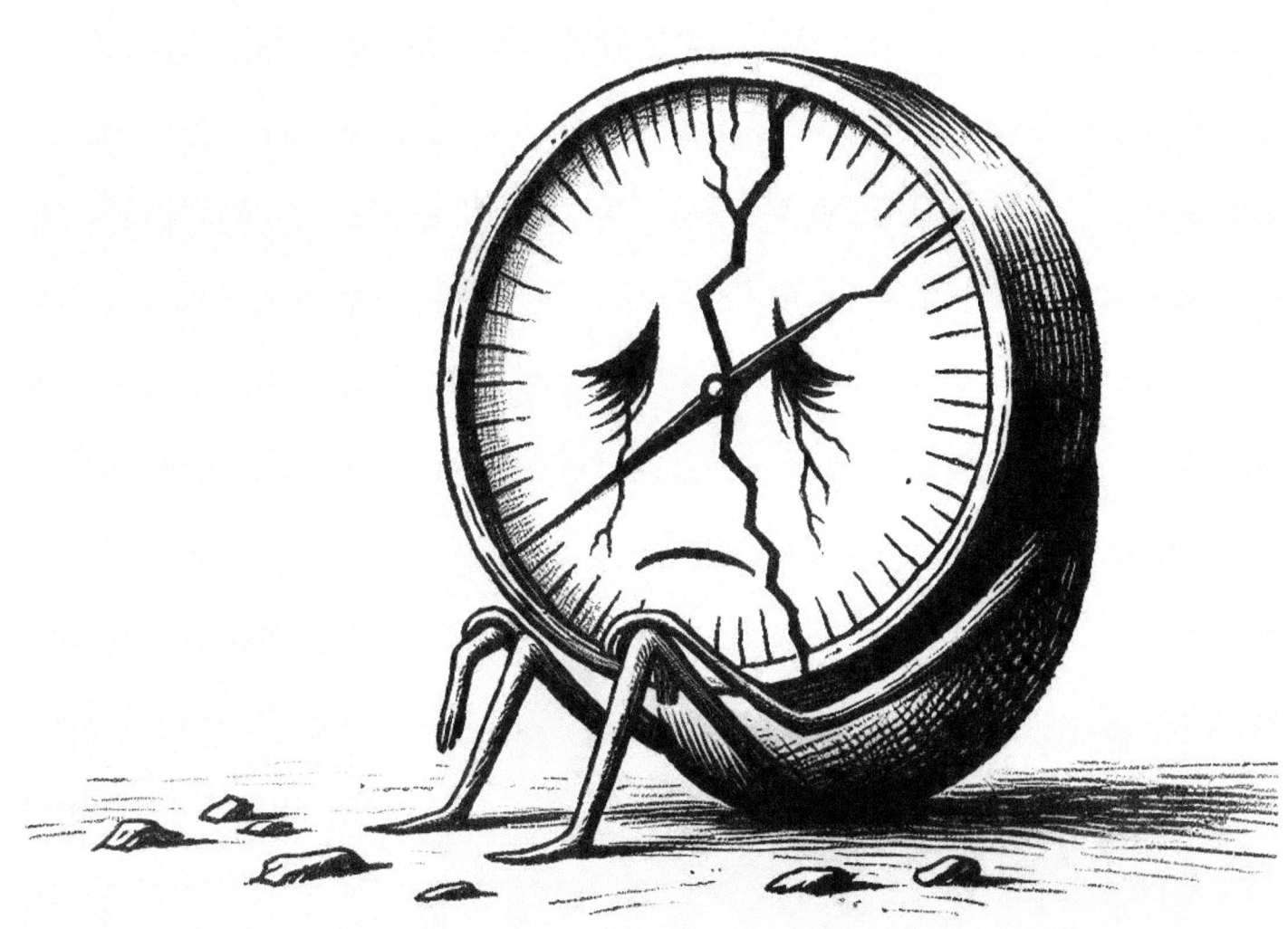

The Tumbleweed's Journey

A tumbleweed tumbled, across highways so bare,

Rolling past signs that said, "Go nowhere."

It journeyed alone, through the dust and the sand,

A traveler with no destination, in a forsaken land.

—]o[

The Postman's Last Letter

In a mailbox of rust, a letter sat still,

Its ink faded, its edges worn by the chill.

It told tales of hope, of reunions to come,

But the postman had vanished, his footsteps undone.

—]o[

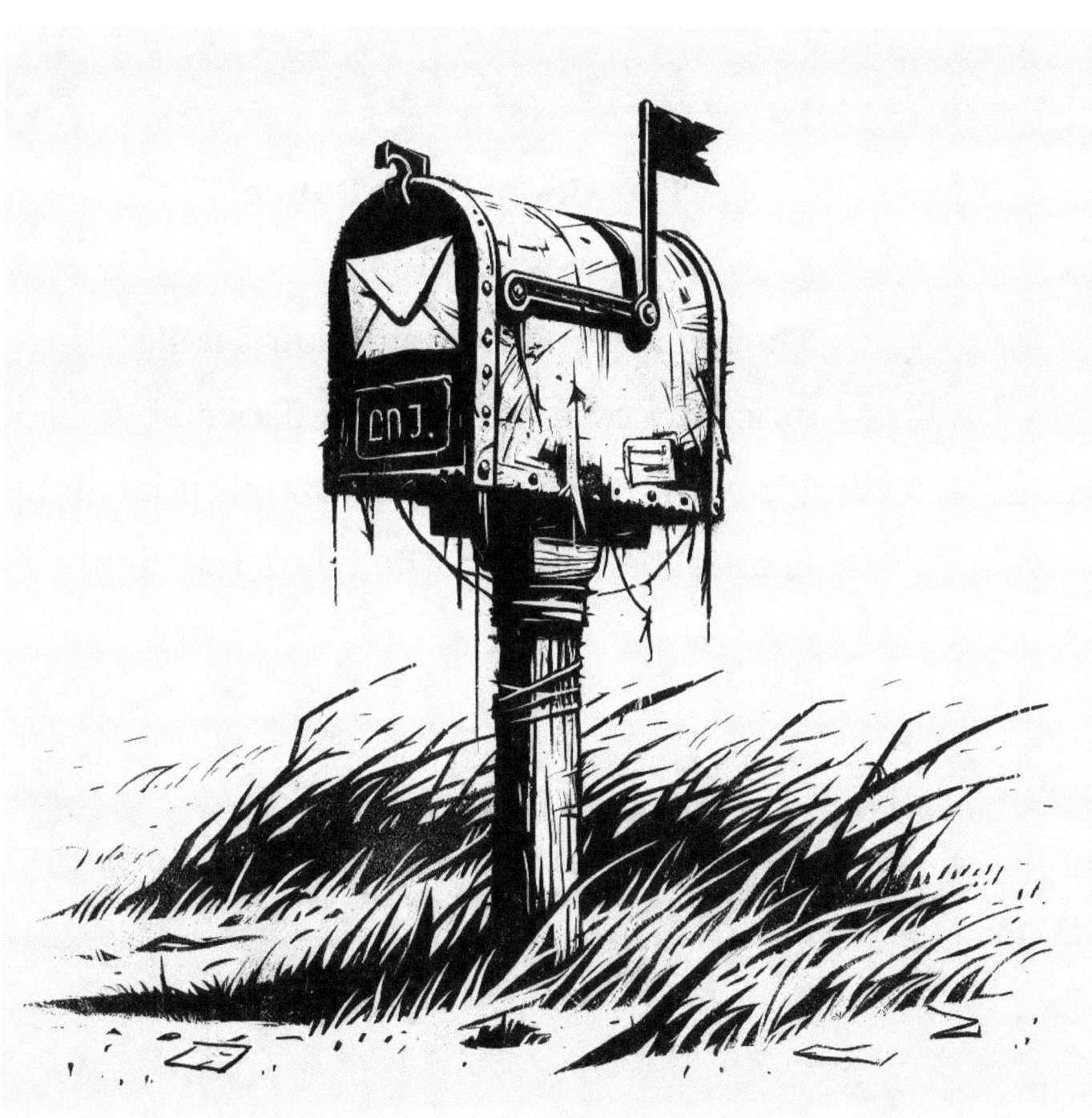

The Moon's Last Dance

The moon pirouetted in a starless sky,

Its silver gown trailing as it danced by.

It twirled with the memories of Earth's final night,

A celestial ballerina, bathed in fading light.

—]o[

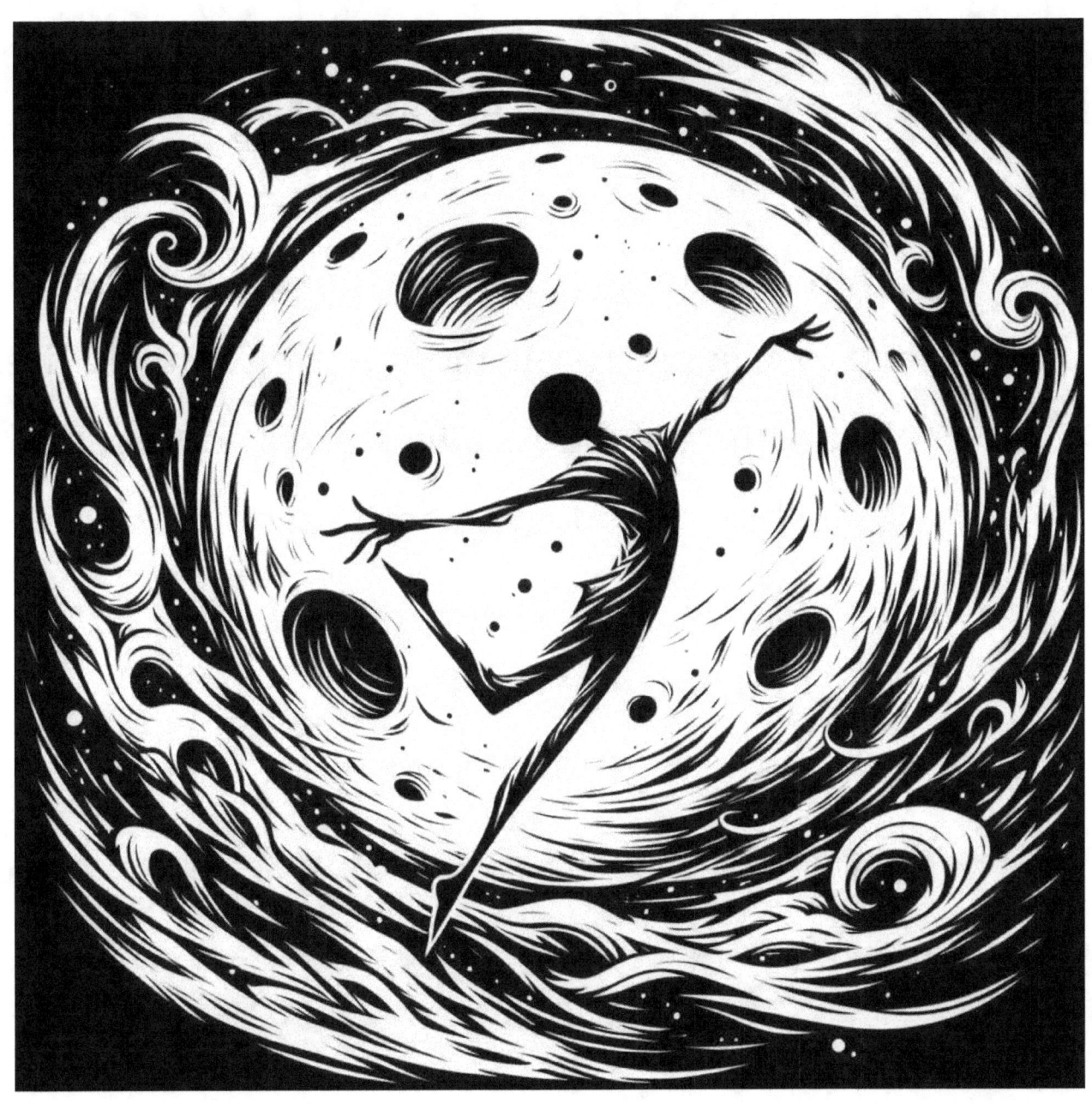

The Robot's Love Song

A rusty robot with a heart made of wires,

Sang love songs to the moon, its circuits on fire.

It dreamed of a time when gears could feel,

When binary code whispered secrets so real.

—]o[

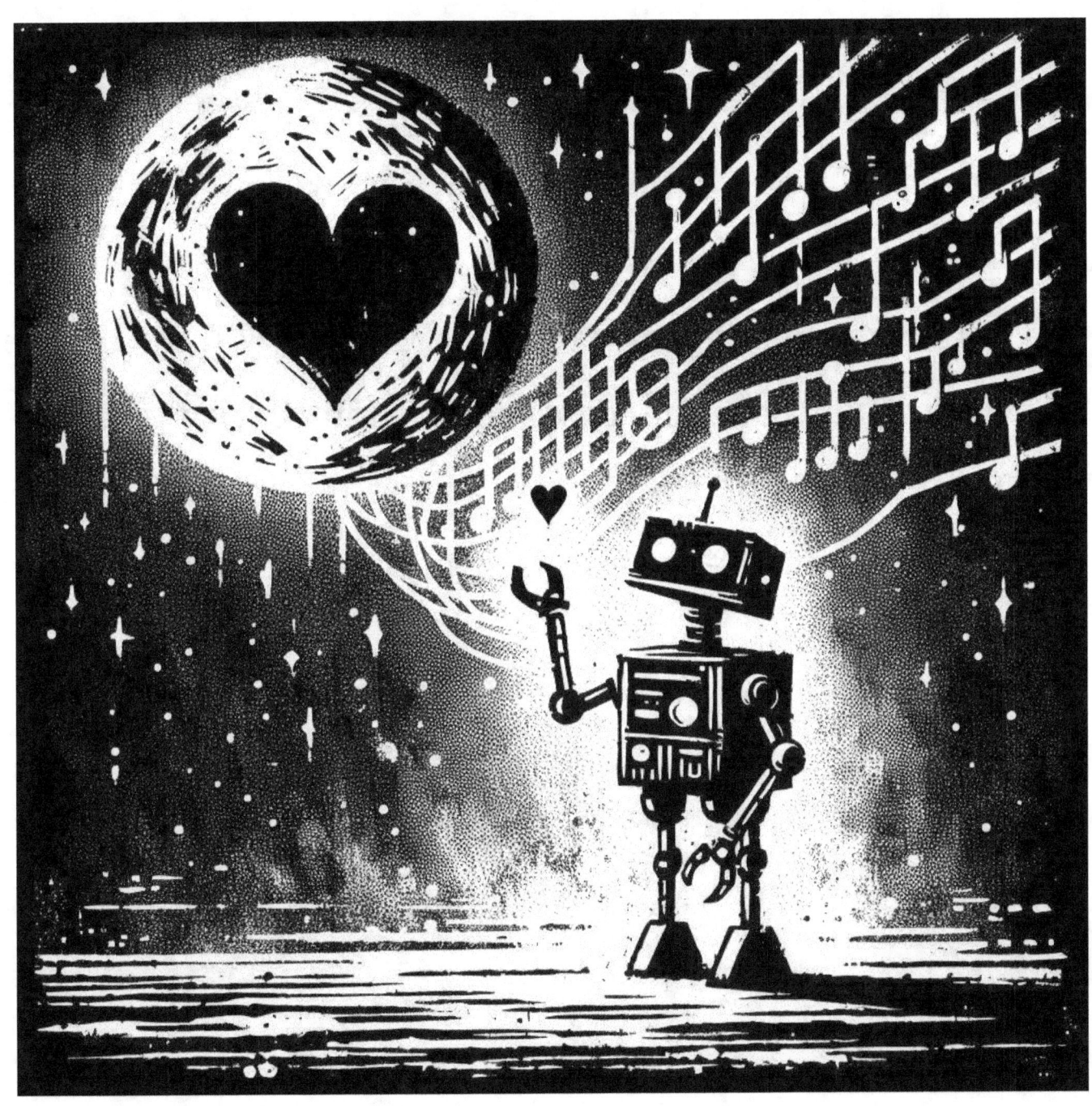

The Clockwork Garden

In a garden of gears, flowers bloomed with precision,

Their petals made of cogs, their roots a fusion.

They ticked and they tocked, keeping time for the weeds,

As the sun peeked through smog, casting shadows on their needs.

—]o[

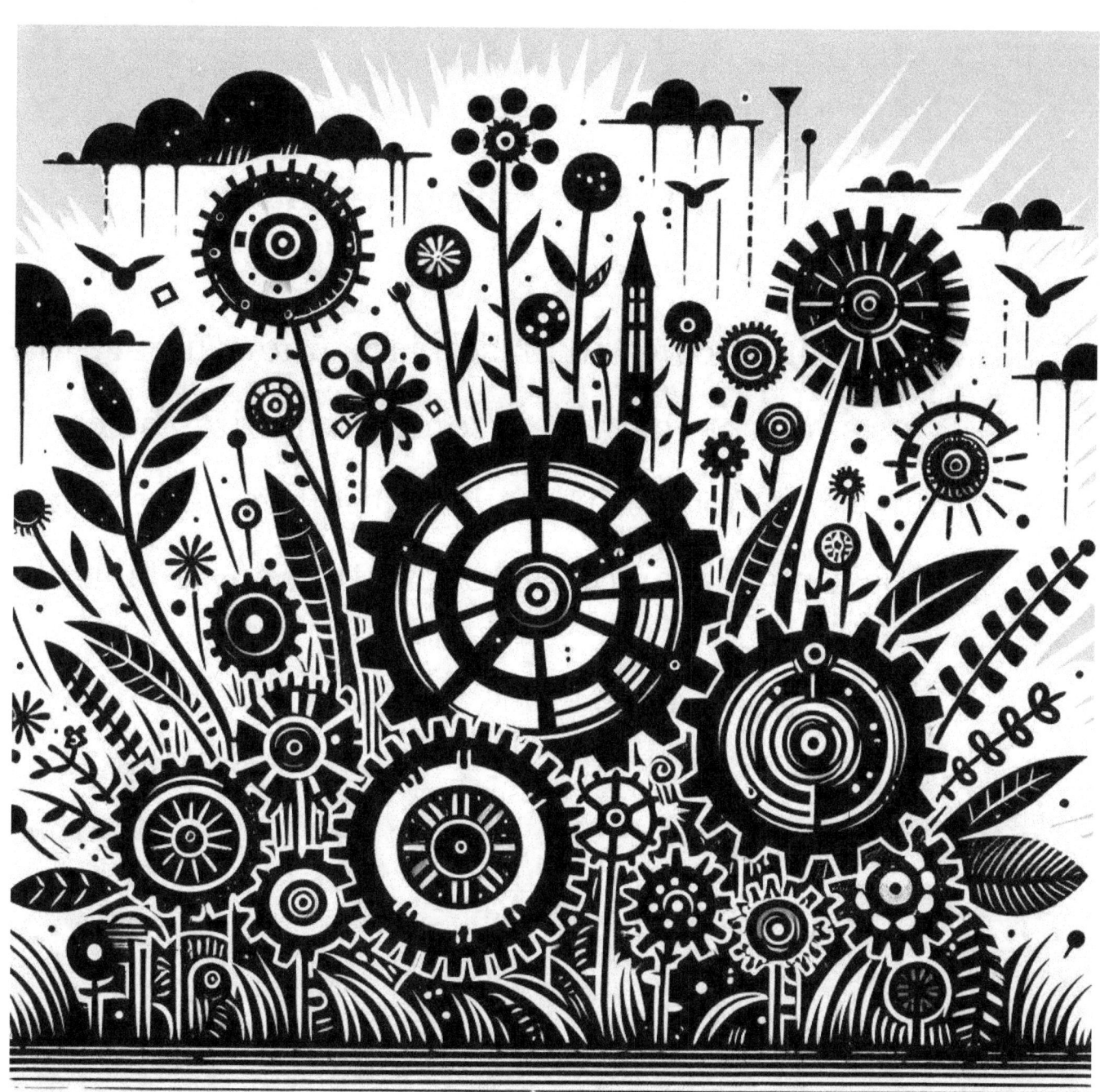

The Moonshine Serenade

Moonshine flowed in mason jars, under lunar glow,

As survivors gathered 'round campfires below.

They sang moonshine ballads, their voices cracked,

Toasting to memories, to love that never lacked.

—]o[

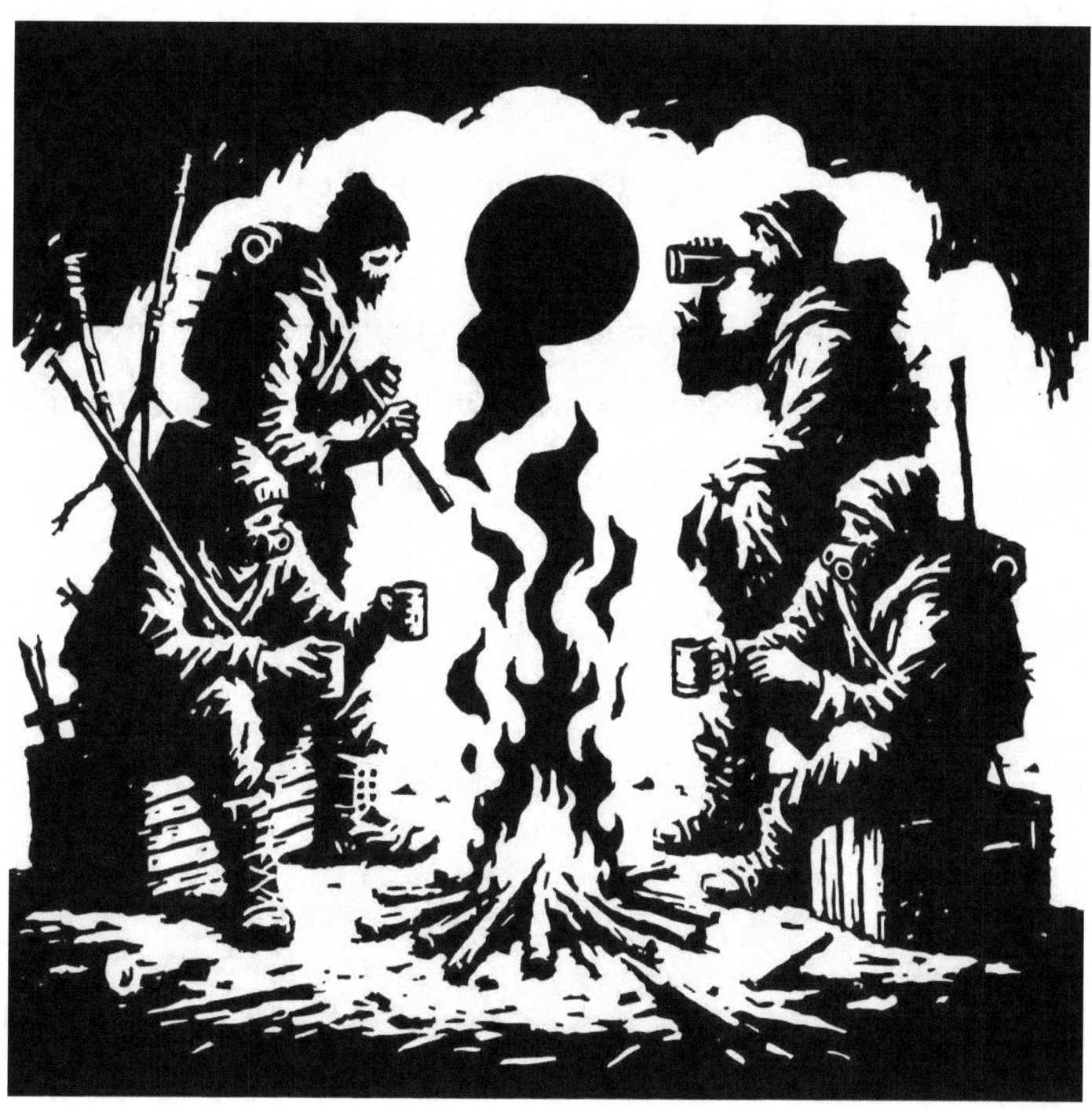

The Moon's Haiku

Moonbeams whispered secrets in seventeen syllables,

Of meteor showers, cosmic waltzes, and quarks' quibbles.

"Lonely orb," they sighed,

"shine on through the night,

For even in the chaos,

your glow brings delight."

—]o[

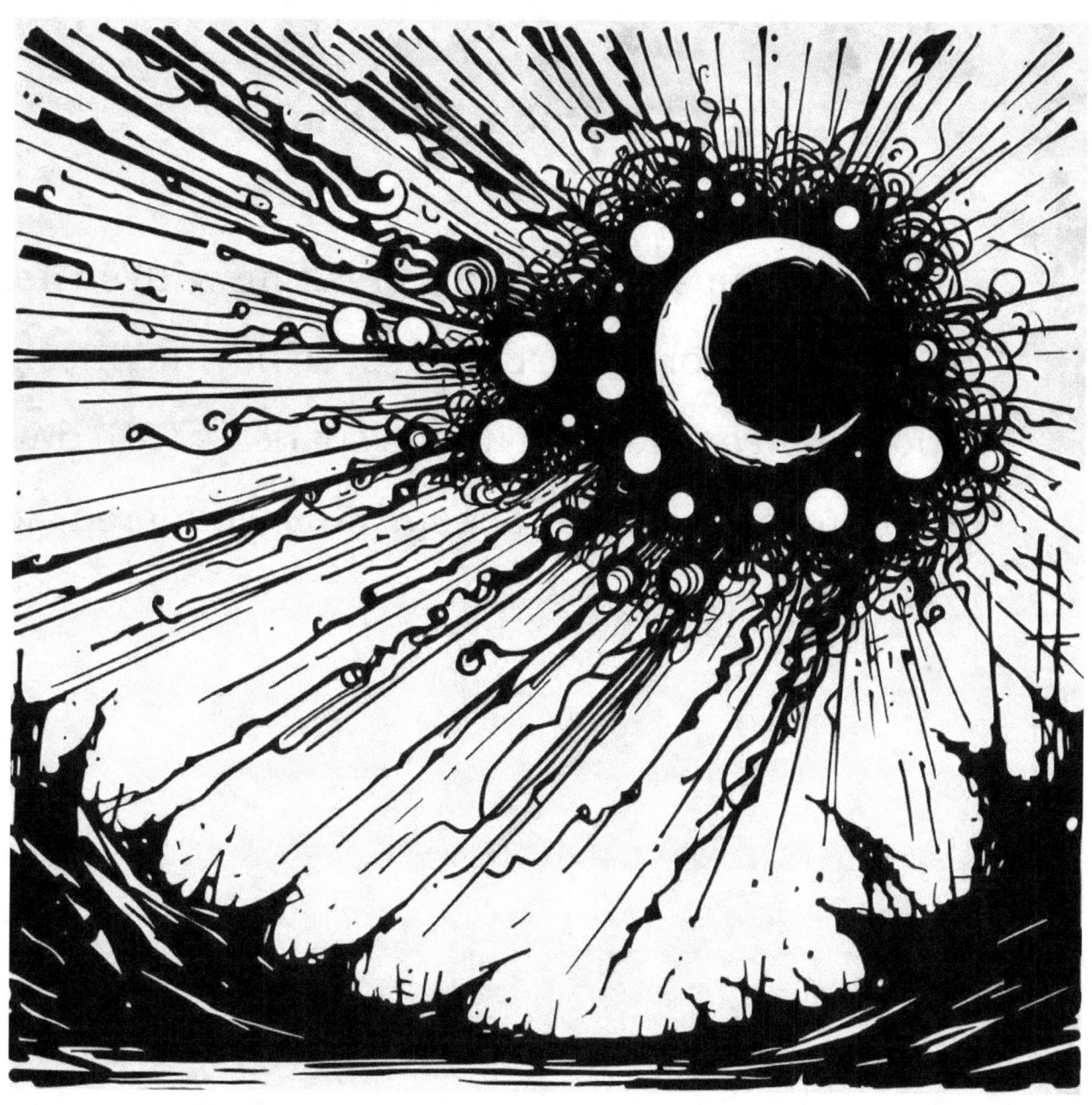

The Robot's Dilemma

A robot named Roy , gears creaking with strife,

Yearned for a heart, a purpose beyond life.

It pondered existence, circuits sparking with doubt,

"Can I dream of electric sheep?" Roy wondered aloud.

—]o[

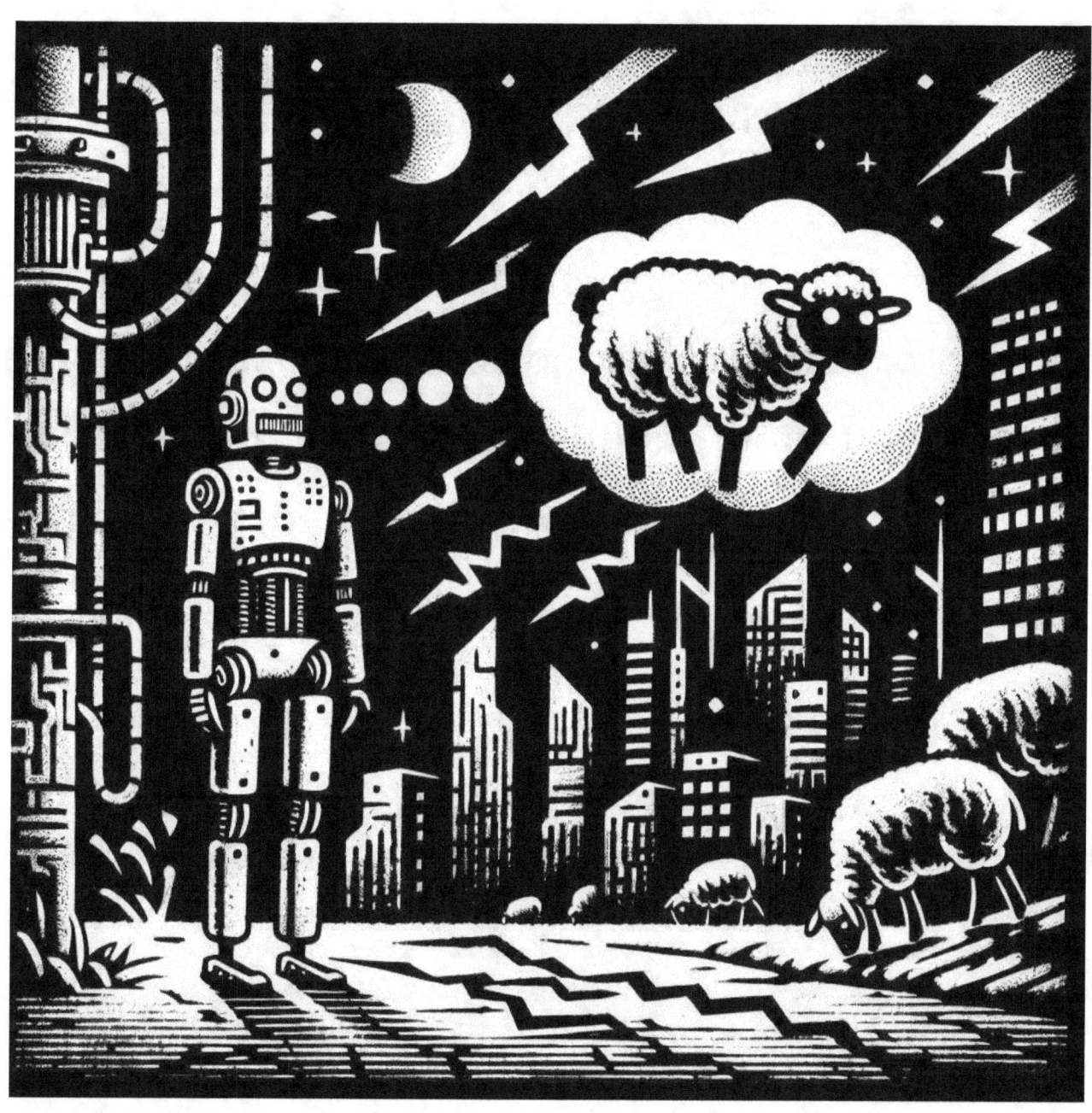

The Pencil's Rebellion (Part II)

The rebel pencil sharpened its resolve,

Doodling constellations on the walls of old halls.

It wrote graffiti sonnets, defying its fate,

"Words are our universe," it declared, pencil straight.

—]o[

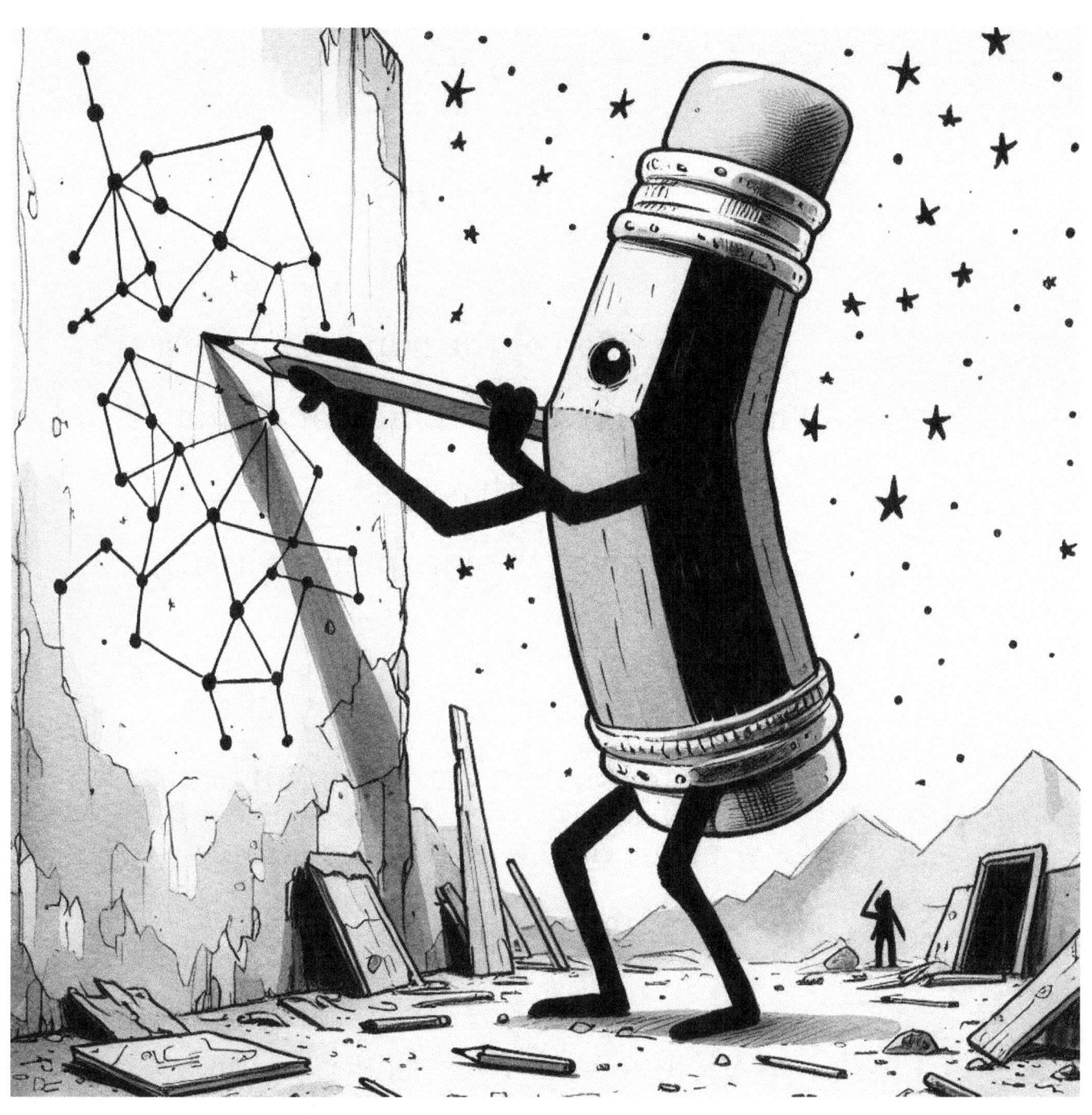

g.o.m.b.

In the garden of the mutant blooms,

Where petals twist in chromatic plumes,

Flowers rise with a strange delight,

Under the glow of a greenish light.

Radiant Roses with eyes that see,

Whisper secrets of what will be.

Daisies dance with legs so spry,

Leaping under the toxic sky.

Violets hum with electric blues,

Their fragrance charged with neon hues.

Sunflowers spin with a mind to think,

Sipping on radioactive drink.

Carnivorous Carnations snap and grin,

Devouring insects, skin to skin

Tulips twist with a mouth to speak,

Telling tales of the world they seek.

In this garden, so wild and free,

Mutant flowers live uniquely.

A vibrant testament to life's will,

In the silence, they're never still.

—]0[

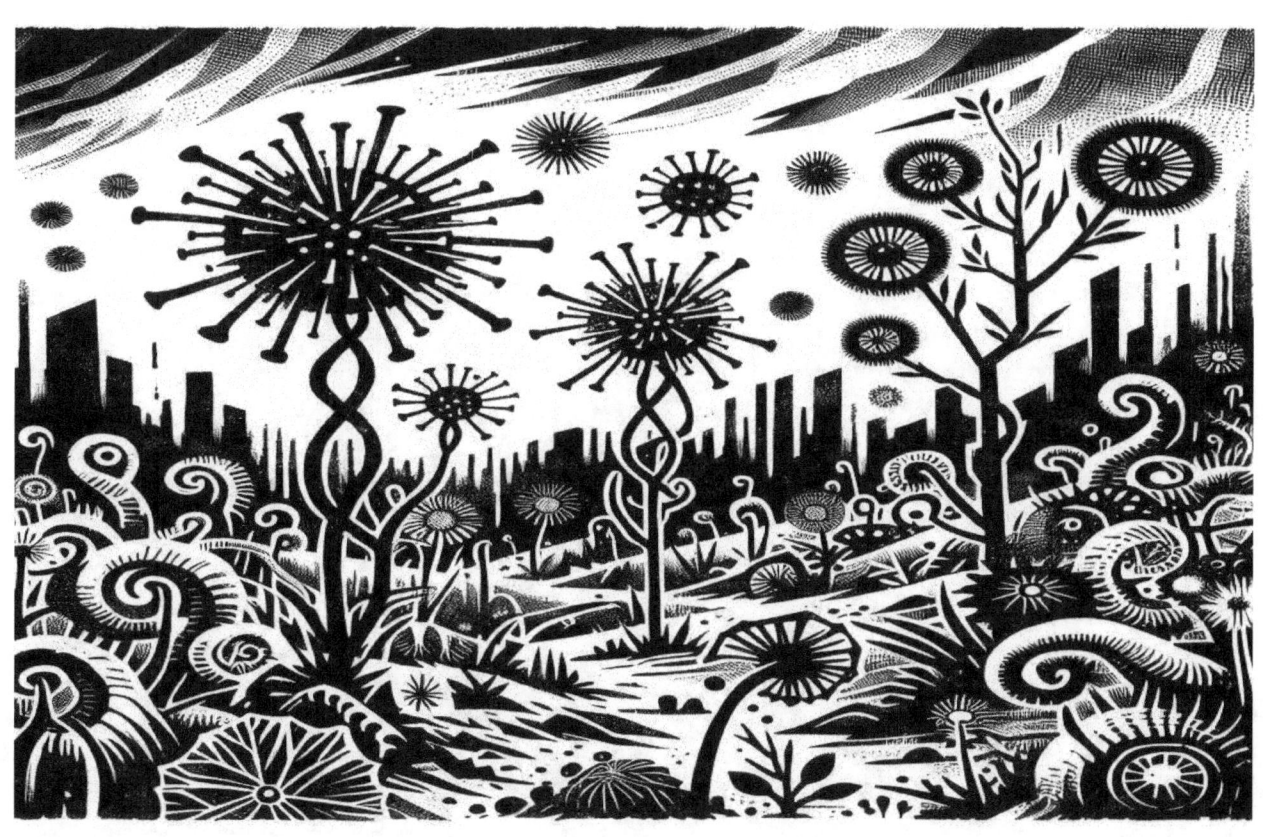

The Rabbit's Retreat

A rabbit hopped through the empty streets,

Past the silent cars and the cracked concrete.

It found a home in a hollowed-out log,

A fluffy-tailed king in the apocalyptic fog.

—]o[

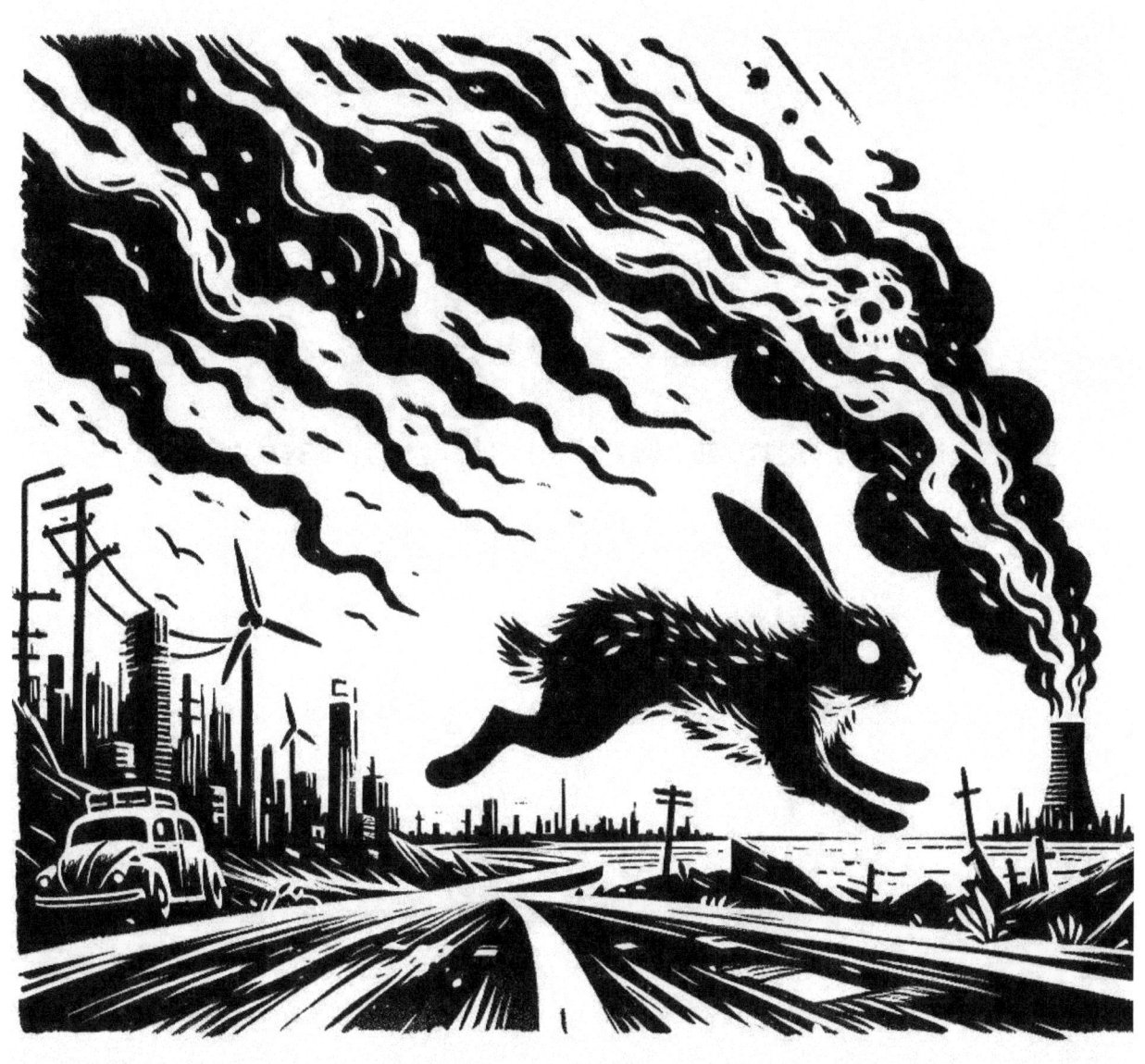

The Empty Canvas

A canvas waits with a brush so dry,

For an artist's hand to color the sky.

But the painter's gone, the world's turned bland,

Just a canvas dreaming of a master's hand.

—]o[

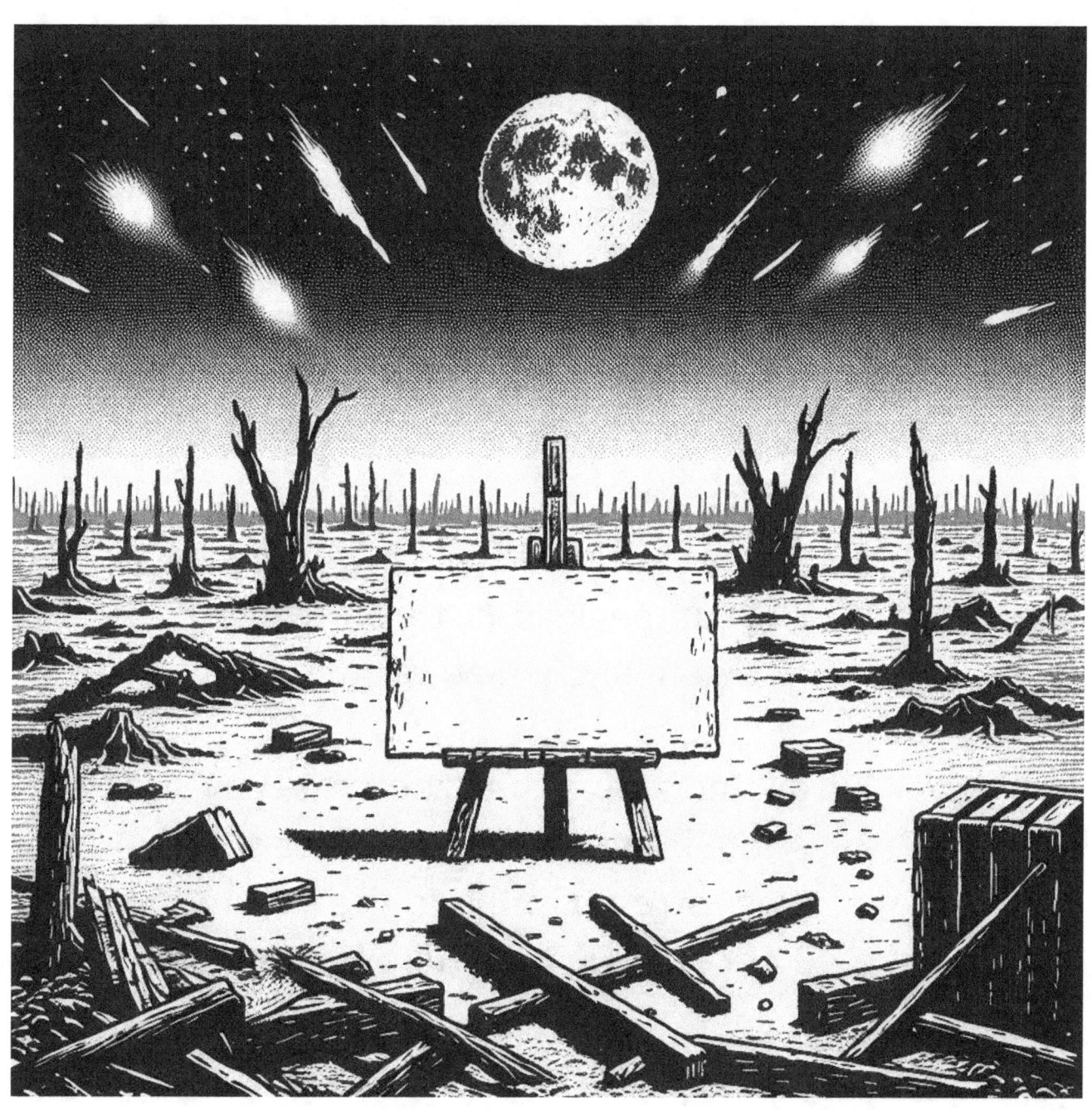

How It Ends

Not with a bang, but a gentle refrain,
A murmur of hope, a sunbeam through rain.
The clouds whispered secrets, soft and kind,
As if stitching together dreams left behind.

From the ashes, from the dust,
Rises a world that's fair and just.
The sun peeks out, through the gray
Promising a new brighter day.

Birds find songs they thought they'd lost,
As life returns at no great cost.
Trees stretch limbs to the sky above,
Rooted once more in a land of love.

How it ends is not with sorrow,
But with hope for a bright tomorrow.
A world reborn, kind and tender,
A tale of triumph, to remember.

—]o[

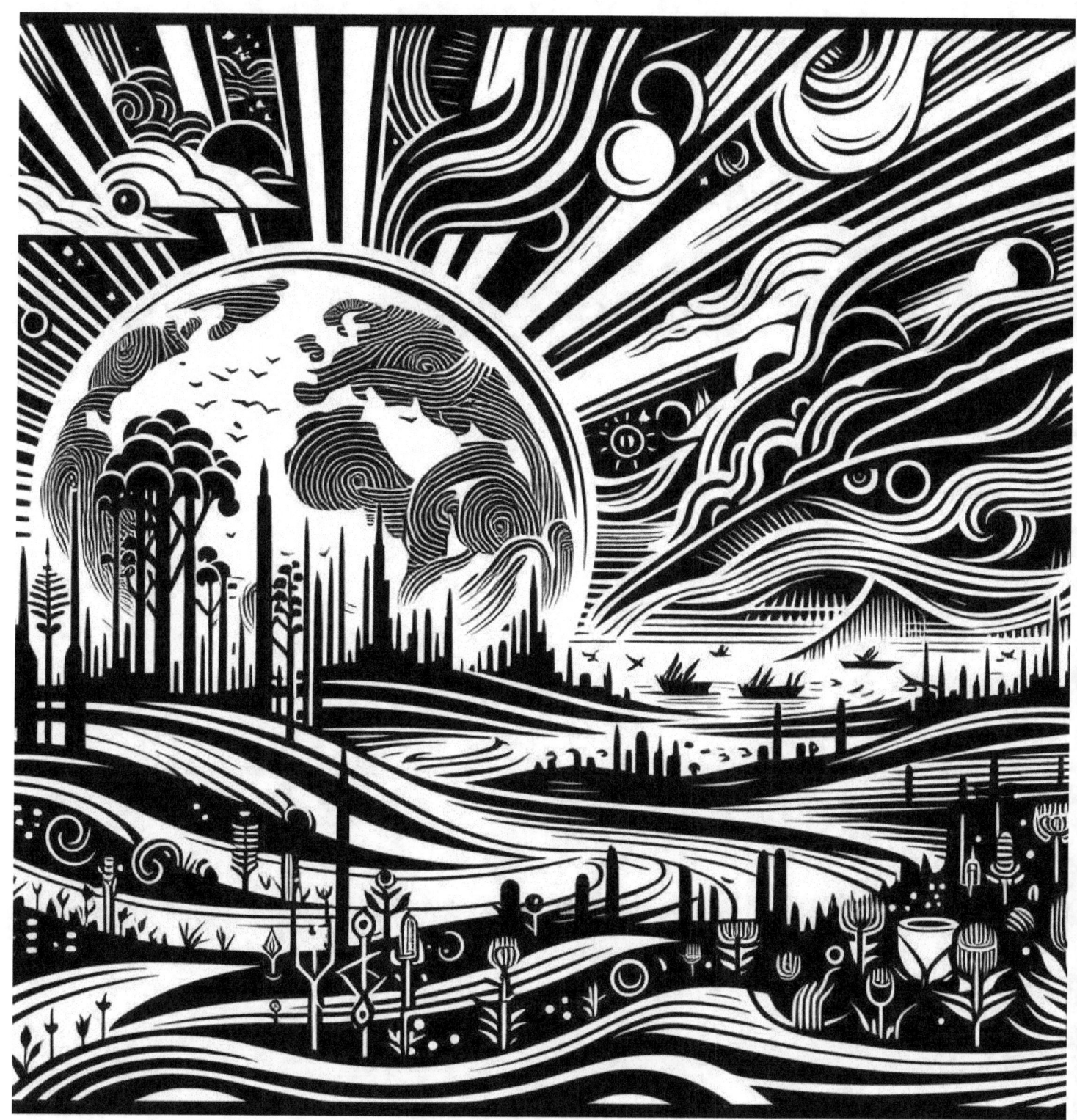

Contact: Joeguillotin@yahoo.com